THE AUTISTIC POSTGRADUATE WOMAN

NAVIGATING THE NEUROTYPICAL UNIVERSITY

DR SOPHIE PHILLIPS

Pavilion
PUBLISHING

The Autistic Postgraduate Woman
Navigating the Neurotypical University

© Pavilion Publishing & Media

The author has asserted her rights in accordance with the Copyright, Designs and Patents Act (1988) to be identified as the author of this work.

Published by:
Pavilion Publishing and Media Ltd
Blue Sky Offices, 25 Cecil Pashley Way, Shoreham by Sea,
West Sussex, BN43 5FF

Tel: +44 (0)1273 434943
Email: info@pavpub.com
Web: www.pavpub.com

Published 2024

All rights reserved. No part of this publication may be reproduced, stored in a retrieval system, or transmitted in any form or by any means, electronic, mechanical, photocopying, recording or otherwise, without prior permission in writing of the publisher and the copyright owners.

A catalogue record for this book is available from the British Library.

ISBN: 978-1-803883-71-7

Pavilion Publishing and Media is a leading publisher of books, training materials and digital content in mental health, social care and allied fields. Pavilion and its imprints offer must-have knowledge and innovative learning solutions underpinned by sound research and professional values.

Author: Dr Sophie Phillips
Editor: Mike Benge
Cover design: Emma Dawe, Pavilion Publishing and Media Ltd
Page layout and typesetting: Emma Dawe, Pavilion Publishing and Media Ltd
Printing: Independent Publishers Group (IPG)

About the author

Dr Sophie Phillips is a research associate at the University of Sheffield, working on a project funded by the Wellcome Trust investigating anti-ableist research cultures. Her research interests centre around increasing access to higher education for autistic women and more broadly neurodivergent individuals, following her own diagnosis as a young adult.

Acknowledgements

In this book, I include the experiences of five postgraduate autistic women who participated in my PhD study: Billy, Cassy, Kim, Poppy and Sarah. First and foremost, I thank them for sharing their experiences with me. I am also very grateful to the Economic and Social Research Council (ESRC) who funded this research, and to my PhD supervisors: Dr Kirsty Liddiard and Professor Dan Goodley, without whom I would not have been able to complete this project.

I also want to thank Louisa from Pavilion Publishing for guiding me through the publishing process, and Dr Amy Pearson and Leanne Naudusevics for their continuous support throughout the writing of this book.

Contents

About the author iii

Acknowledgements v

Foreword 5

Preface 9

Chapter 1: Introduction 13
 A note on autism 16
 Chapter summaries 17
 Who is this book for? 19
 References 20

Chapter 2: Autism in women 23
 Theoretical influence 25
 Media influences 28
 Gendered autism experiences at university 34
 References 37

Chapter 3: The challenges of working while studying 43
 Placements 45
 Being employed in academia alongside studying 48
 References 56

Chapter 4: Being an autistic autism researcher 59
 Some cautions 60
 The potential benefits 63
 Exposing my own autistic identity as a researcher 65
 Navigating the autism research community 68
 References 71

Chapter 5: Navigating Conferences 75

Networking 77

Presenting 87

The overall experience 89

References 90

Chapter 6: The sensory environment of the university 93

The sensory experience in university spaces 94

Libraries 94

Lecture theatres 98

Accommodation 100

The shared office 103

Social events such as student union nights 104

References 107

Chapter 7: Learning differently 111

The expectation of negativity from learning differently 112

Language mismatch 116

How to be autistic in academia? 118

Changing academic expectations 120

References 122

Chapter 8: Autistic advocacy 125

Self-advocacy 126

The element of time 131

Advocating for others 133

References 137

Conclusion 141

A brief reflection on my PhD journey 142

A note on relevance 143

Potential change 144

A final note 145

References 146

Figure list

Figure 3.1: Student Pastoral Meeting, by Cassy 51
Figure 5.1: The Conference, by Cassy ... 78
Figure 5.2: The Broken Mask, by Katie .. 83
Figure 5.3: The Conference Presentation, by Katie 87
Figure 6.1: Untitled, by Billy ... 96
Figure 6.2: Sensory Stimuli in a Lecture, by Kim 98
Figure 6.3: Untitled, by Sarah ... 101
Figure 6.4: The Lego Office ... 103
Figure 8.1: Untitled, by Billy ... 128

Full colour resources are available online at
www.pavpub.com/the-autistic-postgraduate-woman-resources
from where they can be downloaded and printed.

Foreword

Going to university is a transformative period for many people, but can be challenging for a variety of reasons including having to meet new people, learning to live independently, and navigating unfamiliar systems. As such, university can be an immense time of self-discovery and growth, but it can also be incredibly stressful. This is especially true for autistic students who may find traditional educational environments inaccessible. Education is often designed with a one-size-fits-all approach and can present significant barriers for autistic students: normative social expectations, sensory overloads, and the pressure to achieve academic excellence. The jump to postgraduate study, however, presents its own set of challenges, with postgraduates often located at the intersection of professional and learner. Demands are higher, expectations are raised, and there are new situations to traverse, such as attending conferences and networking with peers.

In recent years we have seen a huge increase in the number of university students disclosing an autism diagnosis (and the recognition that universities support many more who either go undiagnosed, or choose not to disclose). Whilst knowledge among university staff is steadily increasing, we still have a way to go in order to ensure that our practice is underpinned by the lived experiences of autistic people and goes beyond reliance on outdated stereotypes. One of these stereotypes is centered around perceptions of who might be autistic. Autistic women and girls (among other groups of autistic people) have historically been overlooked, and absent from narrative and research. This has meant that the knowledge which has filtered into professional practice has (up until very recently) missed out on their experiences.

This book is a much-needed contribution to understanding, that grew out of the author's overwhelming urge to ensure that autistic women navigating academia do not have to experience the same barriers and misperceptions that she did. Through personal narratives and in-depth analysis, Sophie explores how autistic postgraduate women navigate the academic landscape and seek to know and be known throughout the process. Her dedication to advocacy is evident, as she offers readers an insightful exploration of the multifaceted experiences that autistic women face in academic settings. This book is not just a collection of stories; it is a vital contribution to the discourse on autism and higher education.

In addressing the needs of autistic women in postgraduate education, this book calls for a re-evaluation of educational practices and societal attitudes. It challenges us to consider how we can create more inclusive environments that recognise and support the diverse ways in which individuals learn and thrive. By highlighting both the difficulties faced and the triumphs achieved, the author provides invaluable insights for educators, policymakers, and anyone committed to fostering a more equitable and understanding educational system.

The impact of this book extends far beyond the realm of academia. It is a source of empowerment for autistic women, offering them a mirror through which they can see their own experiences reflected and validated. It is also a crucial resource for allies and advocates, equipping them with knowledge and empathy to support and champion the needs of autistic individuals in all aspects of life.

I am thrilled to see this wonderful work supported by Pavilion as part of a growing collection on autism. Books like this remind us that every voice matters, and that by listening and understanding, we can build a more inclusive and compassionate world.

Amy Pearson
Autism Researcher and Assistant Professor in Psychology, Durham University

Preface

This book centres on the experiences of postgraduate autistic women in higher education (HE). I primarily wanted to write this book to contribute to the very small but growing body of literature written by autistic people about their experiences in a predominately neurotypical world. In particular, autistic postgraduate women students are a subset of the population that has not received much attention, maybe due to societal stereotypes linking educational attainment and autism 'severity'. Autistic people who are able to attend university may wrongly be assumed to not require support or understanding. The support an autistic person may need is highly variable, and while I do not dispute that a person who cannot attend university is more likely to need more support than somebody who does, I think it is important to acknowledge and share the different experiences of all autistic people.

I was officially diagnosed as autistic in 2014, towards the end of my undergraduate degree, when I was 21, after struggling socially on school-based placements. Initially, I felt like I was being labelled because I was 'a problem' and an autism diagnosis situated any difficulty I had within me, and absolved the university of any blame or need to support me. I started looking for literature about other people's experiences of being autistic, particularly written by autistic women and autistic students, but I was unable to find any accessible literature that felt relatable to me. I wanted to know about the lives of other autistic adults as I did not feel that I fit into the world at this point and I had recently been given a label that marked me as different. The literature that I did find tended to focus on autistic boys/men or autistic people who did not communicate verbally. It was at this point, after deciding to go on to further study, that I wanted

to contribute to research about how autistic people experienced university. Within the academic literature at this time, there were only three journal articles about the specific topic.[1] My aim in undertaking postgraduate study was to understand myself better, as well as to hopefully make a difference for others. I wanted to challenge some of the stereotypes that surround autism – stereotypes which I discuss throughout this book.

Specifically, my PhD focused on the experiences of autistic women at university. I wanted to keep the focus broad due to the little literature available when I started my PhD study. I therefore framed this research as exploratory. Autistic women studying both at undergraduate and postgraduate levels participated. In this book, I only focus on the experiences of the postgraduate participants. This is because, as I progressed through my PhD, more research on the undergraduate autistic experience began to be published, but research into the autistic postgraduate remained (and remains) rare. Ultimately, I wrote this book to illuminate some experiences autistic women (myself, and the participants of my PhD study) highlight as poignant or impactful as postgraduate students. I hope that in contributing to the small amount of research and literature available, this book will encourage more research focus on autistic women in postgraduate education and offer ways for universities to improve their ways of working and support of these students.

1 Research of this kind is sometimes referred to as 'me-search'.

Chapter 1:

Introduction

Autism has become a societal fascination, one that regularly features in popular media, attracts attention in research and is often the centre of news controversies. Despite this growing interest, the stereotypical image of autism mainly affecting boys remains, and the documented outcomes – particularly for non-cis gendered men – remain poor. Research specifically into autistic women's experiences or issues that affect them is minimal and generally presents negative experiences; for example autistic women are at greater risk of mental health difficulties and increased risk of sexual violence (Grove *et al*, 2023). Cage *et al* (2024) report that, in a survey of 225 autistic adults living in Scotland exploring what aspects of the autistic experience they would like to be researched, issues impacting autistic women was ranked fifth (out of 25 research topics). Listening to the experiences of autistic women and reducing stereotypes of autism could help to change perceptions and broaden society's understanding of autism. Paricos *et al* (2024) emphasise that interest is slowly increasing in research with and for autistic women. This book contributes to that research.

One such area of research where autistic women's accounts are rarely featured is their experiences with academia. Within the relatively small research field looking at university experiences from autistic people's points of view, very little appears to focus on the postgraduate autistic experience. Botha (2021) argues that autistic people are 'not meant' to speak about their experiences in academia, but rather stay silent. Farahar and Foster (2021) pose that, until recently, the autistic experience was coloured by many stereotypes (including regarding gender and

intelligence), which may explain the dearth of research into this area and the lack of shared experiences by individual academics. They go on to say that, until recently, as autistic academic women, they would have been considered 'rare people' (2021, p200). Research into the general university experience for autistic people is slowly growing, but the experiences of autistic postgraduate students (especially women) are largely ignored or only touched on in single accounts and autobiographies (for example in Farahar & Foster, 2021; Stewart, 2018). There is a small amount of literature exploring the experiences of disabled postgraduate students – Shinohara *et al* (2021) is a notable example. They consider visually impaired doctoral researchers and noted that these graduate students had to work harder than other students to achieve similar prospects. I especially choose to focus on autistic postgraduate students due to the frequency with which they are ignored in research in favour of undergraduate autistic students.

Throughout this book, I draw on both my own lived experience, some themes of my PhD research and relevant research. This means I am able to provide both an insight into lived experience, but also to review relevant literature through my own autistic lens. My PhD study focused on the experiences of autistic women at university. The overall aim of the research was to present the participants' experiences to help address the lack of research at that time focusing on non-cis-gendered autistic men. Eleven autistic women participated, and of these six were studying at postgraduate level. Participants were asked to create up to three artefacts and participate in an interview. The brief for the artefacts was that they needed to depict how they felt their autism had impacted them at university (in a positive, neutral or negative way) and had to be produced in a way that could be emailed to me. Superficially, the majority of the artefacts and words I have included may appear to only depict negative experiences, but when explored further, consist of a mixture of emotions that cannot neatly be defined as positive or negative. Originally, I had simply planned for these artefacts to be springboards for discussion, but they became central to the research due to the creativity and quality that was evident. I therefore wanted to showcase them as widely as possible. Throughout this book, I incorporate the artefacts the participants created. These all appear in black and white, however, the colour images can be accessed in the online resources for this book.[2]

2 www.pavpub.com/the-autistic-postgraduate-woman-resources

I briefly want to introduce the reader to the six participants that feature throughout this book, presented in alphabetical order, to describe what they were doing at the time and to give the reader some context into their lives. All participants, except Poppy, chose to use a pseudonym in the research. I removed any identifying information participants said from their interviews:

- **Billy** was studying for a PhD in a scientific discipline. She viewed autism as a difference, but thought that if society saw autism as a difference then it would not acknowledge the difficulties that she sometimes had or appreciate that she could have 'bad days'.

- **Cassy** was a lecturer and also head of her university department. She was undertaking a PhD as part of her staff development. Cassy self-identified as autistic, after having discussions with professionals who worked with her two children who were formally diagnosed. Her father was a priest, meaning that she grew up having to regularly socialise with different types of people. She felt like she and her family had to perform, even when she did not want to socialise. During the research, Cassy was keen to draw attention to the difficulties of needing to socialise in the university context, such as during networking at conferences.

- **Katie** was formally diagnosed as autistic six months before participating in the research and had found it difficult to navigate the process of diagnosis, but also to receive support before she had formal paperwork. She was in her final year of a psychology PhD. Katie was keen to highlight that being autistic included good and bad aspects, and she thought using art was a powerful way of showing the emotion of this.

- **Kim** was studying a postgraduate taught course. She described autism as complex, challenging and difficult, but something special. Kim spoke a lot about how society's views of autism was based on stereotypes and stigma.

- **Poppy** was a postgraduate student who also taught. She was waiting for a formal autism assessment and also had other neurodivergent labels such as dyspraxia and ADHD. Poppy considered the intersectionality between these labels and how a variety of different aspects of a person's identity affected the way in which a person was treated at university.

- **Sarah** was studying a postgraduate teaching course, having recently completed a PhD in the field of creative writing. Before being diagnosed as autistic three years before the research, she had been

misdiagnosed with mental health conditions including schizophrenia. Sarah questioned if her life would have been different had she known she was autistic earlier, as she had lived a lot of her life without this knowledge and with wrong labels being applied to her.

A note on autism

Autism is described and understood in many, sometimes unfavourable, ways. In terms of medical diagnostic manuals, autism is said to be a neurological disorder (American Psychological Association (APA), 2013). If a person is diagnosed with autism, they are said to have difficulties in social communication and interaction, and social imagination that limit and impair everyday functioning (APA, 2013). Difficulties in social communication and interaction might include not enjoying social gatherings. Social imagination difficulties might consist of processing sensory stimuli differently. Autism has tended to be presented as a series of deficits compared to the norm, rather than as differences, and autism therefore tends to be portrayed in a negative light (Cooper *et al*, 2021). This medicalised view of autism is criticised by some, particularly as autism currently has no known aetiology. Some researchers argue that it is a different way of thinking (Anderson-Chavarria, 2021) whereas others (for example, Runswick-Cole *et al*, 2016) question whether autism should exist in its own right. In essence, there is a lack of agreement in society about what autism is, who can be autistic, and whether it exists as a disability. This appears to fuel societal stereotypes, alongside a contentious but progressive research field. For autism, regardless of whether it is scientifically considered as real, it is likely to be considered *societally* real. Therefore, while I acknowledge that there are ongoing debates about the scientific reality of autism, this is beyond the scope of this book. I choose to start from the point that autism exists and therefore the experiences of autistic people need to be highlighted to improve inclusion and diversification.

The language that should be used to describe autism and autistic people is frequently debated (for example, Botha *et al*, 2021; Dwyer *et al*, 2022). Debates tend to centre around how to describe autism (for example, terminology such as Autism Spectrum Disorder) or whether to use identity-first language (such as 'autistic person') or person-first language (such as 'person with autism'). Debates about describing an autistic person broadly focus around whether autism is part of a person's identity or an

additional part of them. However, there seems to be a lack of consensus on the preferred type of language surrounding autism (Bottema-Beutel *et al*, 2021). It is widely acknowledged that professionals tend to prefer person-first language, whereas autistic people prefer identity-first language.

There is more consensus about how to describe autism. Although what constitutes and describes autism has been termed differently in different diagnostic manuals, for example, as Autism Spectrum Disorder (ASD), Asperger's Syndrome and Autism Spectrum Condition (ASC), there is a general acceptance that all these different terms can be simplified to just 'autism'. In addition, the language that is used to describe the autistic experience is much less regularly considered, but may also perpetuate stigmatising attitudes and beliefs. For example, Pearson and Rose (2023) suggest that 'special interests' be referred to as 'passions' as it evokes more positive attributions. While there is no one accepted language convention in society, it is perhaps best to either ask the autistic person what they prefer, or, if speaking more generally, to briefly explain one's choice of words.

Within this book, I use identity-first language to refer to autism, and refer to autism as 'autism'. This is purely my personal preference as I think of autism as part of my identity and I do not believe that I would be the same person if I did not 'have autism'. Therefore, my identity as a person and autism cannot be separated. I have also chosen to use specific terms throughout the book to aid consistency. Although terminology of any concept, identity or idea are important, I do not seek to exclude any reader who prefers to use other terms to describe language about autism or begrudge their choices. I would prefer the concepts of what I am speaking about to be debated, rather than interest to stop at a debate about language. However, I do urge any reader who does not agree with my language choice to consider how language can impact specific individuals and the importance to them of following their preferences.

Chapter summaries

In Chapter 2, I will discuss some of the stereotypical and stigmatising societal beliefs that surround autism, focussing particularly on those that apply most to autistic women who go to university, such as myths about autistic people being like television characters. I consider how autism is viewed through a gendered lens and the impact that can have.

In Chapter 3, I explore how postgraduate students may be employed in academia alongside studying. I present the experiences of six participants from my PhD research. In the role of a student, the educational environment may be supportive, but the same support and accommodations may not be available as a member of staff, despite being inside the same building or university.

In Chapter 4, I consider the benefits and challenges that being an autistic researcher in the field of autism research might present. I also explore how it is encouraged in research to be flexible towards the participants, but not necessarily the researcher. Bringing together both the culture of autistic researchers in research and the practicalities that an autistic autism researcher may need, I highlight how autistic postgraduate researchers may have to navigate challenges that non-autistic researchers do not.

In Chapter 5, I explore how being autistic does not just impact and affect the university experience within 'the four walls' of the university building. I highlight that, although efforts are made within the university to implement reasonable adjustments, the provision at conferences and on placements (and other activities associated with postgraduate life) attracts less focus.

In Chapter 6, I discuss some areas of the university that may provide sensory challenges to autistic women. I again draw on experiences from the participants in my PhD research and present several of their artefacts that so vividly explain how an environment can be impactful in a way that words alone rarely can. I highlight how it is not just the physical environment but also the way in which other people behave in a space that can have an effect on the way in which an autistic individual experiences a place.

In Chapter 7, I consider how feeling different may affect autistic postgraduate women, both in terms of completing academic work and how they view themselves as an autistic person in academia. I also explore whether there is a specific way to be autistic in academia.

In Chapter 8, I explore advocacy, both in terms of advocating for oneself and advocating for others, and I examine how advocacy can produce both positive and negative outcomes, both for the cause and the individual. I consider the element of time – how, in relation to advocacy and implementing support, slowness can be harmful, but that an autistic person may be advocating for more time.

Finally, I conclude this book by drawing together themes of both inclusion and exclusion that I have explored throughout the previous chapters. I re-visit the 'unseen' challenges autistic women in postgraduate education may experience, with reference to further intersectionality.

Who is this book for?

This book is aimed at anybody who is interested in gaining insight into how autistic women may experience postgraduate study at university. My intention is that both autistic people aiming to go into postgraduate study and non-autistic people interested in expanding their knowledge about autism and lived experience will find this book helpful. The scenarios, explanations and research I present are not a definitive guide to how all autistic women will experience university, however I hope to provide some insight into the types of situations they may encounter by sharing my story and highlighting research including others' experiences. On the same theme, I do not seek to provide an exhaustive account of all related literature.

This book may also be relevant to anybody with an interest in Universal Design for Learning (UDL). UDL is about meeting the needs of learners by being proactive and thinking ahead rather than adjusting based on a student disclosing a need (Burgstahler, 2015; Creaven, 2024). For example, captioning on videos should be provided as standard, as opposed to somebody needing to ask for this as a reasonable adjustment at every event they attend that includes videos. This proactivity means that inclusion is incorporated from the beginning when planning about teaching, rather than as an afterthought, which is often the case. This then reduces the need for 'reasonable adjustments' as the environment has already been adjusted. UDL originated in early years education but is becoming more popular in university education to increase inclusivity (Spaeth & Pearson, 2023). UDL could remove the need for autistic individuals in academia to regularly disclose their identity or repeatedly advocate for access. Cumming and Rose (2023) highlight that, in principle, disclosing any disability should be unnecessary if a UDL approach is adopted. UDL is still developing and not the norm in universities, and the majority of documented research focuses on learning about UDL rather than the effectiveness of UDL in practice (Creaven, 2024). I hope the stories I share in this book will promote

the need to universally adopt a more inclusive culture in higher education, whether that is by building on the principles of UDL or the implementation of something different.

Overall, I aim to spark discussion and further interest in the experiences of autistic postgraduate women at university, both to highlight the positive experiences they have and barriers they face, in order to promote change. I hope that this book will contribute to the growing body of literature focusing on the autistic experience, particularly that of autistic women.

References

American Psychiatric Association (2013). *Diagnostic and statistical manual of mental disorders: DSM-5*. (5th ed). American Psychiatric Publishing

Anderson-Chavarria, M. (2021). The autism predicament: models of autism and their impact on autistic identity. *Disability & Society*, 1-21. https://doi.org/10.1080/09687599.2021.1877117

Botha, M. (2021). Academic, activist, or advocate? Angry, entangled, and emerging: A critical reflection on autism knowledge production. *Frontiers in Psychology*, **12**, 727542. https://doi.org/10.3389/fpsyg.2021.727542

Botha, M., Hanlon, J., & Williams, G.L. (2021). Does Language Matter? Identity-First Versus Person-First Language Use in Autism Research: A Response to Vivanti. *Journal of Autism and Developmental Disorders*. https://doi.org/10.1007/s10803-020-04858-w

Bottema-Beutel, K., Kapp, S. K., Lester, J. N., Sasson, N., J., & Hand, B. N. (2021). Avoiding ableist language: suggestions for autism researchers. *Autism Adulthood*, **3**, 18–29. https://doi.org/10.1089/aut.2020.0014

Burgstahler, S. (2015). *Universal design in higher education: From Principles to Practice* (2nd ed.). Harvard Education Press.

Cage, E., Crompton, C. J., Dantas, S., Strachan, K., Birch, R., Robinson, M., Morgan-Appel, S., MacKenzie-Nash, C., Gallagher, A., & Botha, M. (2024). What are the autism research priorities of autistic adults in Scotland? *Autism*, *0*(0). https://doi.org/10.1177/13623613231222656

Cooper, R., Cooper, K., Russell, A. J., & Smith, L. G. E. (2021). I'm proud to be a little bit different: the effects of autistic individuals' perceptions of autism and autism social identity on their collective self-esteem. *Journal of Autism and Developmental Disorders*, **51**(2), 704–714. https://doi.org/org/10.1007/s10803-020-04575-4

Creaven, A. M. (2024). Considering the sensory and social needs of disabled students in higher education: A call to return to the roots of universal design. *Policy Futures in Education*, 1-8. https://doi.org/10.1177/14782103241240808

Cumming, T. M., & Rose, M. C. (2022). Exploring universal design for learning as an accessibility tool in higher education: a review of the current literature. *Australian Educational Researcher*, **49**, 1025–1043. https://doi.org/10.1007/s13384-021-00471-76

Dwyer, P., Ryan, J. G., Williams, Z. J., & Gassner, D. L. (2022). First Do No Harm: Suggestions Regarding Respectful Autism Language. *Paediatrics*, **149**(Supplement 4), e2020049437N. https://doi.org/10.1542/peds.2020-049437N

Farahar, C., & Foster, A. (2021). #AutisticsInAcademia. In N. Brown (Ed.), Lived experiences of ableism in academia: Strategies for inclusion in higher education (pp. 197-216). Policy Press.

Grove, R., Clapham, H., Moodie, T., Gurrin, S., & Hall, G. (2023). 'Living in a world that's not about us': The impact of everyday life on the health and wellbeing of autistic women and gender diverse people. *Women's Health*, **19**. https://doi.org/10.1177/17455057231189542

Paricos, A., Sturrock, A., Twomey, K., & Leadbitter, K. (2024). I'm not mad, bad, and dangerous... simply wired differently: Exploring factors contributing to good quality of life with autistic women. *Research in Autism Spectrum Disorders*, **112**, 102338. https://doi.org/10.1016/j.rasd.2024.102338

Pearson, A., & Rose, K. (2023). *Autistic Masking: Understanding Identity Management and the Role of Stigma*. Pavilion Publishing.

Runswick-Cole, K., Mallett, R., & Timimi, S. (Eds.). (2016). R*ethinking Autism: Diagnosis, Identity and Equality*. Jessica Kingsley Publications.

Shinohara, K., McQuaid, M., & Jacobo, N. (2021, May 8-May 13). *The Burden of Survival: How Doctoral Students in Computing Bridge the Chasm of Inaccessibility* [Conference presentation]. CHI Conference on Human Factors in Computing Systems 21. New York. https://doi.org/10.1145/3411764.3445277

Spaeth, E., & Pearson, A. (2023). A reflective analysis on how to promote a positive learning experience for neurodivergent students. *Journal of Perspectives in Applied Academic Practice*, **11**(2), 109-120. https://doi.org/10.56433/jpaap.v11i2.517

Stewart, C. (2018). Diversity, Gender, Intersectionality and Feminism. In B. Cook & M. Garnett (Eds.), *Spectrum Women*. (pp. 56-68). Jessica Kingsley Publishers.

Chapter 2:

Autism in women

Autism as a concept has existed for approximately 100 years. In the UK, it is suggested that one person in every 100 is diagnosed with autism (Brett *et al*, 2016). However, the 'diagnosis' of autism and its validity is a regularly contested issue (Fletcher-Watson & Happé, 2019). The exact definition, symptomatology and aetiology of autism are widely debated. This is particularly due to the lack of any conclusive diagnostic medical evidence. The term 'autism' is documented to be first used by Bleuler (1908) to describe schizophrenic patients who were severely withdrawn from society. Kanner (1943) and Asperger (1944) conducted further studies of children who displayed behaviour that was unexplainable by any diagnostic label at the time. Both Kanner and Asperger used 'autism' to describe the children in their studies and are widely credited as the researchers who initiated autism as a pathological condition. Since then, autism as a concept has been widely accepted to exist, although there are many medical and societal debates around its origin, diagnosis and commodification.

Despite a relatively short-documented history of less than 100 years, some very fixed ideas about autism have developed which dominate the mindsets of those who study the condition as well as the public at large. For example, autism can be viewed as a solely Western condition. Although it is increasing in prevalence worldwide (Chiarotti & Venerosi, 2020), it is frequently seen as a condition that predominantly affects Western society with high technological development, in particular the UK and USA (Bakare & Munir, 2011). Grinker (2018) argues that disparities in economic development between countries are not the sole reason for this

diagnostic disparity and that there is a multitude of reasons, including stereotypes and lack of awareness of why a supposedly scientifically validated condition is seldom recognised. Some continents, for example Africa, output less research into the prevalence of autism (Bakare & Munir, 2011), whereas in Italy, autism is seen as a 'way of being'. Therefore, people with exactly the same symptoms may attract different labels (or no labels) depending on the country and cultural context in which they live.

One of the most prominent debates centres around the relationship between autism and girls/women. Autism is considered a particularly controversial diagnosis in girls and women, regardless of how it interacts with other intersections of people's identities. In 2017, Loomes *et al* suggested the male-to-female ratio of diagnosis of autism was 3:1, although the gender-diagnosis ratio had previously been suggested to be as low as 1.8:1 (Mattila *et al*, 2011). This ratio of 3:1 suggests that autism occurs more frequently in girls and women than previously thought, and therefore the impact of autism on girls and women is greater than once realised.

Early thinking by Asperger suggested that autism was 'a variant of male intelligence' (Asperger, 1944, p39), therefore implying that girls and women could not be autistic. Wing and Gould (1979) are though to be the first researchers that specifically highlight that autism also occurs in women. Although they published their research over 40 years ago, autistic women can still be subject to both discrimination and oppression. This may be because the experiences of autistic women are repeatedly under-represented in research (for example, Hoyt & Falconi, 2015; Milner *et al*, 2019; Seers & Hogg, 2021). This lack of inclusion in research may be contributing to the lack of knowledge in society (and, by extension, universities). Milner *et al* (2019) argue that, in order to reduce common societal gender stereotypes surrounding autism, autistic women's experiences need exposure. Seers and Hogg (2021) highlight that girls and women tend to be encouraged to partake in traditionally feminine roles, which may mean that autistic girls and women try harder than autistic boys to fit into this societal discourse, leading to longer time spent undiagnosed.

In this chapter, I specifically discuss how autism is biased towards cis-gender (a term for those identifying as the gender they were assigned at birth) males and neglects those without this gender, particularly women. Before delving into specific issues at university that may affect an autistic postgraduate woman in later chapters, I think it is important to understand

some of the history of autism in women and how autistic women are portrayed in society. I then turn to some examples of the gendered experiences that participants in my PhD study and I have had at university.

Theoretical influence

The link between autism and feminist theories of disability

As I stated in the introduction to this book, autism can be viewed as either a difference or a disability. I predominantly view autism as a disability due to how society views autistic women, but would like it to eventually be seen as a difference. I am unsure whether autism being a difference or a disability should be viewed as dichotomous, however it is important to consider both viewpoints to understand how autism is contemplated within society and to explore some of the theory behind this. Stenning (2022, p2) beautifully explains this as follows:

> *'While not all autistics consider themselves disabled, Garland-Thomson's definition of misfitting allows us to think about the realities of living with impairments and the contexts against which abilities are measured.'*

Autism viewed as a disability, particularly in women, can be difficult to understand. Ultimately, being a disabled woman does not neatly fit with feminism (the advocacy of women's rights based on equality of the sexes) and therefore it is questionable whether being considered 'disabled' somewhat removes the rights women strive for through feminism.

Feminism emerged from the belief that women should have the same rights as men in terms of social, political and economic power (Bowden & Mummery, 2009). It champions women and pushes back against a society dominated by the patriarchy. Disability and disabled women (particularly those with autism) occupy an awkward space within feminist studies (Lloyd, 2001; Morris, 1998; Serra, 2015) due to being historically given a vulnerable role in society by both feminists and non-feminists. It is inarguable that the majority of women have gained some positives from feminist campaigns, such as the right to vote, but this may still exclude some disabled women where others refuse to

accommodate their disability (for example, disabled people who are detained or in institutions). In addition, although feminism seeks to promote equality between women and men, it remains relatively fractured around intersectional differences. Some disabled feminists have argued that mainstream feminism fails to promote equality between disabled and non-disabled women (Barnes, 2022; Garland-Thomson, 2002). This hierarchy could mean that autistic women strive to not identify as disabled in order to be accepted in the wider society of women. This is particularly important to think about as being part of multiple oppressed groups (such as being autistic and a woman) can be thought of as a 'double disadvantage'. This could be expanded to mean a 'triple disadvantage' and so forth. Morris (1993) argues that although disabled women's lives are shaped by how disability and gender interact, non-disabled writers' use of 'double disadvantage' highlights what disabled women are 'supposed' to experience and this removes any responsibility from society to seek to reduce this disadvantage in society. In addition, Morris (1996) also considers that if people are always oppressed by terms (for example 'disabled' and 'woman'), they will begin to internalise these oppressions and to conform to the expectations that society holds about them.

Considering feminist writing tends to ignore disability, some researchers (for example, Garland-Thomson, 2002; Morris, 1996; Thomas, 2006) wanted to ensure that disability is incorporated to extend the current cultural notions feminism provides in order to unite the category of being a woman, in a space which disabled women do not easily occupy. Feminist disability studies therefore emerged to bring feminism and disability studies together to embrace the awkwardness in qualitative methodologists (for example, Simplican, 2017) and therefore promote change for disabled women. Thomas (2006) is another influential writer in the field of feminist disability studies. She argues a disabled person constructs their disability in relation to perceived gender norms. However, Thomas (2006) argues that disabled people should not just be categorised into 'disabled women' and 'disabled men' and seen solely as disadvantaged by both disability and gender. She says that other parts of a person's identity also attract discrimination, for example race and sexuality, which creates a much more complex picture of how a person is disadvantaged or excluded. Thomas (2006) does however highlight that the gendered realities of being disabled are important to explore. In the context of autism, gender is very important to hold at the forefront as at the moment society appears to view autism most prominently in conjunction with this intersectionality.

Another interesting feature of feminist disability theory which could be relevant to autism research is the Misfit Theory (Garland-Thomson, 2011). Garland-Thomson posits the concept of 'misfits', which she explains to be the awkward attempt to put or place two things together that do not fit. There is no problem with each thing in itself, but their 'shapes' do not join together. She highlights that contextual and temporal shifts can allow a better fit between two things over time. With regard to disability, Garland-Thomson describes 'fitting' to be between a body and the environment, and while a perfect fit may never exist, there is a spectrum between perfection and imperfection along which we all sit. She suggests that everybody should encompass their vulnerabilities and acknowledge where they may fit or misfit into the environment (regardless of whether they have a disability label), thus accommodating disability as a variation of being human. Thus, misfit theory can shift individuals between difference and normalcy. McKinney (2014) and Price (2015) highlight the simplicity of this model as it tends towards physical disability, for which the physical environment can be changed. However, the concept of fitting into a group or identity beyond the physical environment may still be relevant for autistic people. Autistic women challenge the notion of fitting into a stereotypical perception of autism and therefore may be considered misfits to both the stereotypes of women and autistic people. Garland-Thomson (2011) argues that there is power in misfitting and challenging concepts of human diversity. An autistic misfit theory could assist in challenging the binary conception of normality and difference. Thus, holding onto the benefits of the misfit theory and attributing it specifically to autism may enhance autistic women's experiences of university.

Theories of autism

Many theories about autism have been constructed and their description of them is beyond the scope of this book. However, one theory – Extreme Male Brain (EMB) theory (Baron-Cohen, 2002), which describes autism to be an extension of the male brain – needs discussion. When relating gender and autism, this theory is potentially the most damaging theory to autistic women. It assumes that a male brain is better at synthesising than empathising and a female brain displays the opposite: that autism can be deemed to display a cognitive profile of extreme synthesising and very poor empathising – thus being an extreme version of the male profile. Baron-Cohen (2002) further hypothesised that these innate differences are due to different levels of exposure to testosterone in utero. However,

these claims lack concrete biological evidence (Grossi & Fine, 2012; Kung *et al*, 2016; Ferri *et al*, 2018). In addition, there is no substantial evidence for brains being biologically constituted for what Baron-Cohen considers 'sex-specific' tasks (Krahn & Fenton, 2012). Despite the potential debate over the biological soundness of the EMB theory, the links between autism and innate maleness have been evidenced through autistic female children demonstrating masculinisation by showing a preference for stereotypically masculine toys that do not require imaginative play (Knickmeyer *et al*, 2008). This theory has been argued to remove 'womanness' from autistic women, as it suggests that one cannot have a 'female brain' and have autism (Ridley, 2019).

Despite scientific criticism, EMB theory is still popular, cementing historic assumptions relating to the binary of gender and differences between cognition and gender. In a society where the dichotomy between maleness and femaleness is dominant and there is less acceptance of a spectrum of genders, this can be particularly damaging. Krahn and Fenton (2012) highlight how attributing human characteristics or traits to a specific gender was deemed problematic by feminist theories in the 1980s, but it is still prevalent today. Theories such as EMB reinforce these assumptions of the gender dichotomy which may be damaging both for and within the autistic community.

Media influences

In addition to theoretical influences, the media can be particularly impactful when influencing stereotypes and public opinion about different populations. Alongside theory that influences research, societal opinions of autistic people that have been influenced by the media are likely to also be present in academia. Autistic television and book characters are frequently portrayed as having a negative impact on their families or on the wider society around them (Brooks, 2018), or having a savant ability (Belcher & Maich, 2014; Bernard *et al*, 2023). There appears to be very few representations of autism that represent 'ordinary people'. Society seems to require stereotypical representations in order to understand autism (Black *et al*, 2019). In my research, Kim suggested:

'When people think of autistic people they either think of a white sixteen-year-old boy that's very good at maths, or they think of a young child who can't communicate properly… or if you're a white man that's very very good at maths, you can just stay in the lab and do your maths and change the world from behind closed doors.'

This presentation of autism (as a white middle-class boy who is good at maths) that Kim talks about is also documented by Matthews (2019), who highlights how common this stereotype is in the media. He says that one popular character that fits all those stereotypes is Sheldon Cooper in *The Big Bang Theory* (Lorre & Prady, 2007), who is frequently used as a reference point within the autism community despite never being explicitly described as autistic in the television programme (Matthews, 2019). This may mean that society does not hold a stereotypical association of what an autistic woman looks like. While stereotypes are not always helpful for those who do not feel they fit them, people rely on them to make sense of the world. Loftis (2021) and McGuire (2016) argue that a metanarrative of autism in the Western world is that autistic people are either children or child-like. In her comment above, Kim notes two presentations that she believes society holds of autism, referring to children on both occasions. Loftis (2021) notes this metanarrative is dangerous for adult autistic people because they are either at fault for not curing their autism or because autistic adults only deserve the same autonomy afforded to children. As the fault lies with the autistic adult under society's favoured narrative, access to services for autistic adults may be reduced and autistic adults are liked to be viewed unfavourably.

The stereotypes of disability, and more specifically autism, that Kim suggests dominate societal discourse. Dean and Nordahl-Hansen (2021) contend that the way in which autism is presented in the media and popular culture influences how society views 'real people' with the label, meaning it is important that the portrayal is correct. I have found this to be true in my own experience, for example on multiple occasions I have introduced myself as autistic (in a relevant context) and either been told I do not look autistic or that I cannot be autistic as I was working on a PhD. Sometimes I have justified this on the basis that a person has only

seen a fraction of my life to base their opinion on, however it is difficult to have part of the make-up of my personhood questioned regularly. I do not believe if I declared other 'invisible' parts of myself I would be doubted in the same way, which I attribute to the current autism stereotypes that exist. Kim had also experienced the same, but she thinks that race as well as gender and autism has impacted society's reaction to her:

> *'I think the socialising, I would be allowed to make more mistakes as a man. I think the response that people give that you don't look autistic might be lesser, especially if I were a white man.'*
>
> (Kim)

The implication of this is that the stereotype of what autism looks like needs to be broadened so that who can be autistic is not policed by society. It may be unlikely that media stereotypes will change, however, because, Murray (2008) argues, that for autism to remain a fascination in popular culture it has to appeal to the majority audience's beliefs and portrayals. This may mean that autistic fictional characters will never accurately represent the majority of autistic people, as these characters have to be extraordinary. Writing over a decade later, Broderick and Roscigno (2021) maintain that the intended audience for most popular media that includes autistic characters is not autistic people, and therefore a portrayal of un-stereotypical people, for example, an autistic woman, may not attract such popularity. This may be why presentations that are more relatable to autistic people are seen less in popular culture.

Christensen (2020) used the metaphor of Harry Potter (Rowling, 1997) in exploring how three Danish autistic women, all of whom had autistic children, viewed autism. She was interested in whether her participants viewed autism as part of a spectrum of normality or solely as a difference. The Harry Potter series does not explicitly state that any characters are autistic and it has not been widely suggested by society that any of them are. However, it could be argued that the series of books is about difference. Christensen's (2020) research discusses how the muggles (non-magical people) could be seen as non-autistic people and the wizards as autistic, as both worlds have different norms and expectations. It is a nuanced construction, however, and wizards can be born to muggle

families (referred to as 'mud-bloods'), demonstrating how different worlds can overlap. Although Harry Potter as a metaphor in Christensen's (2020) research is not used to specifically describe autistic women, it explores how difference can be shown without explicitly labelling it. While JK Rowling herself does not necessarily portray herself in the media at present as being open to all differences, her books highlight difference within their storylines. For example, outside of the books, JK Rowling has stated her position that Hogwarts is an inclusive environment, particularly in regard to ethnicity and sexuality. However, despite this, from her comments on trans rights it appears that, much like our university system, Hogwarts inclusiveness only extends so far. This therefore begs the question of whether characters should be introduced as explicitly autistic or whether popular media should simply focus on ensuring a variety of people are represented in order to champion intersectionality rather than reinforce stereotypes. Or whether a variety of differences should occur, such as having multiple characters with a certain disability label with explicitly different personalities and needs.

Although not specific to autism, popular media has long included disability and difference as key features. Barnes argued in 1991 that humour that is overtly racist or sexist can be censored but that disability humour and poor representation remain acceptable, which suggests disability is a lesser protected characteristic. Some more recent research highlights that there is some movement to changing stereotypes within popular media. Alice and Ellis (2021) posit that the film franchise *Shrek* (Adamson & Jenson, 2001) subverts the traditional narrative of a fairy tale and that the films show both social exclusion and disablement, and interdependence and disability pride through characters that rebel against traditional roles and expectations. Shrek, an ogre, is the hero of the films and depicted as a non-normative body. Garland-Thomson (1997) argues that monstrosity (either through a literal or metaphorical monster) tends to be shown in films in comparison to the normative body, therefore representing disability. Alice and Ellis (2021) highlight that although Shrek is viewed as a monster and an outcast, he is also depicted as finding community with others and challenging internalised ableism. This therefore depicts the complex nature of disability. Representations in society of disability as more complex, including in popular media and media aimed at children, compared to stereotypically negative depictions, may encourage society to view disabled people more as part of society, rather than being othered.

There is an argument that autistic characters in the media in more recent times are diversifying and becoming more complex (Aspler *et al*, 2022), although other researchers, such as Ressa and Goldstein (2021), argue that autism stereotypes in the media remain unchanged. In recent years, some autistic women have sought to challenge this erasure in public discourse by writing about their own stories, both with and without academic slants. Cook and Garnett (2018) begin their edited collection of stories of their and other autistic women's experiences by highlighting how the reader can immerse themselves in their book. They go on to say that the stories presented offer support for other autistic women 24 hours a day. The emphasis that Cook and Garnett (2018) place on their book being supportive, immersive and insightful is notable. This highlights the dearth of material available about autistic women's lives and to spotlight that their book is one of the rare collections of stories by autistic women. The inclusion of autistic protagonists is, however, slowly evolving in popular children's fiction, such as in Smale's *Geek Girl* series (first published in 2013). Smale is open about her neurodivergent identity.

The inclusion of autistic women in both the sharing of stories and fiction falls on autistic women themselves, which suggests that although there are advocates seeking to reduce the erasure of autistic women in society, the acceptance of this development by non-autistic people may be minimal. One research participant noted that perhaps there is an increase in understanding about the varied nature of autism, regardless of gender which could be due to better media portrayal or societal understanding:

> *'It may not be a gender thing so much but it might be that we're recognising that there's more than one way to be autistic.'*
>
> (Cassy)

This comment suggests that if, and as, autism is more widely known and understood, gender may not play a large part in society's construction of it, particularly in relation to stereotypes. However, at the current time, portrayals of less stereotypical autistic people, such as autistic women and girls, may exist less explicitly and less frequently in media, possibly because autistic women and girls are more able to mask their symptoms or because autism in women is viewed as less common and less acceptable

in society. Townson and Povey (2019) support this suggestion, recognising that even though there is an increase in media portrayals of autistic women (including celebrities disclosing their autistic identities), they argue that autistic women are still routinely discriminated against. They indicate that this may be due to a time lag between media presence and societal knowledge, and so in the future could be beneficial to autistic girls and women, but, currently, stigma and erasure remain commonplace. If autism was recognised to present in many different ways, as Cassy alludes to, rather than being subject to gender stereotypes (such as autism relating to boys who are very good at maths), then autistic women may not be as marginalised. This is likely to extend to the knowledge of staff and other students at university.

Autistic women's minimal exposure also appears in non-fictional media, which may also influence the stereotypes held by people at university. Greta Thunberg (an autistic climate change activist), for example, is one of the few autistic women who does appear prominently in non-fictional media. However, as a white teenage activist, she is exceptionalised by the media, who regularly highlight her autism as a 'superpower' (Ryalls & Mazzarella, 2021). Moriarty (2021) deems this depiction of autism to be 'supercrip'[3], as Thunberg is seen as challenging her disability in inspiring ways. However, while Greta Thunberg is championing her cause and publicly highlighting herself as autistic, possibly to challenge negative stereotypes of autism, not all autistic women or their families will find her relatable, especially if they do not view autism as a 'superpower'. For other autistic people, it may be demoralising. Spies (2021, p308) states that 'It can be frustrating and limiting, especially if people are attempting to live as a supercrip'. While some autistic people being able to achieve exceptional things is impressive, a link between autism and 'superpowers', for example in the university context, may lead to damaging ideas that autistic students do not need support, when in fact they do, regardless of their academic ability.

Representation through theory and in both fiction and non-fictional media can both showcase and poorly characterise autistic people. These representations can then positively and negatively affect societal opinions and stereotypes in ways that are likely to be more damaging for autistic women.

3 The term supercrip tends to refer to the stereotypical depiction of disability in contemporary fiction. Disabled people tend to be portrayed as inspirational or heroic (Schalk, 2016).

…

Chapter 2: Autism in women

Gendered autism experiences at university

Societal representations of autism can help promote inequity (Janse van Rensburg, 2022), as has been highlighted through the work of critical autism scholars such as Milton (2014) and Woods *et al* (2018). Much autism discourse focuses on how autism 'symptoms' vary depending upon a person's gender (Moore *et al*, 2022), rather than how autism is experienced by different people. In my PhD study, participants spoke about the perceptions, including stereotypes, they thought society held about autistic women and how these influenced their experiences in the community. Although these are only their perceptions and may not be an objective fact, the messages the autistic women are receiving are important to acknowledge to ensure that they feel that they are represented fairly and accurately. In relation to gender and autism, participants' views were overwhelmingly negative, feeling that they were dismissed for being unable to conform to the expectations that society held about autism should look like. Poppy expressed that she felt it is acceptable to be autistic as a man, but not as a woman:

> *'People's idea of autism is very different depending on if you're male or female… I think that people, like, I don't really know what people's idea of an autistic woman looks like, and I think that people are very clear of what an autistic man looks like, so they sort of try and cater to that person, whereas maybe the autistic woman is something they haven't got an idea of [and] sort of reject that outright.'*
>
> (Poppy)

Poppy suggests that, because what an autistic woman looks like is not what people think autism looks like, society simply dismisses them. Seers and Hogg (2021) explored the experiences of eight autistic women in order to better understand how psychological and societal constructions of autism affected wellbeing. Within their study, they suggest that autistic women are expected to conform to the same societal expectations of non-autistic women but may respond to them in unconventional ways. They suggest that although autistic women may not be as inherently interested in gender

norms as non-autistic women, they are interested in others' judgements and stigma. This in turn can influence how autistic women want to act and conform. The intense focus that Seers and Hogg (2021) suggest that society places on all women to conform to the same expectations may be difficult for autistic women. Thus, as Poppy suggests, a stereotypical image of an autistic woman may be helpful for autistic women as something that is easier to conform to – especially when societal perceptions of what a woman should look like appear so ingrained. Seers and Hogg (2021) conclude their study by suggesting that, as society's narrow, essentialist view of gender norms expands, and as gender becomes perceived as a continuum, rather than a binary construct, considering autism through a gendered lens may become redundant. However, views and opinions can take a long time to change and to reach a point at which autism is considered without a gender bias may therefore not occur for many years.

This notion – that a stereotypical 'autistic woman' does not currently exist and that autistic women are therefore not considered – proved problematic for some of the participants. Cassy and Poppy experienced stigma or ignorance from others at university for being autistic women because of their gender:

> *'I often get told there is no way you can have that kind of score on the autism spectrum or you know the autism quotient or anything like that, because you are so good with people.'*
>
> (Cassy)

> *'When someone asked me, when I told … one of my colleagues that someone had asked me if I was autistic, she just found it hilarious, like, the fact that someone might think that about me.'*
>
> (Poppy)

Similar experiences are reported in research by Borsotti *et al* (2024). They explored the access needs of neurodivergent students in three university-level computer science institutions and documented that

women participants tended to report more surprised and unbelieving responses than male participants. Poppy and Katie gave examples of how they thought their identity as autistic women affected how other people at university considered them compared to how they would have been considered as autistic men:

'One example is that I have run into trouble on many occasions for sending emails that have the wrong tone and I don't think that would happen if I was a man. I don't think people would care about my tone in general, if I was a man and I think, like, I've run into trouble because it feels like I'm telling people ... the most recent information. I think it's seen as me being really impertinent and, like, stepping out, or, like, talking above my place, whereas I think if I was a man, people would just see it as, like, part of who I was and not, like, dig into it as, like, being me.'

(Poppy)

'I get lots of feedback, things like in presentations saying I'm quite blunt. And I'm not sure a man would be described as blunt. So I think there's maybe a discourse difference as well.'

(Katie)

These comparisons Poppy and Katie draw about tone and bluntness, which they think in an autistic man would not be subject to comment, highlights how societal stereotypes of autism have become ingrained in their thinking.

Societal perceptions of autism can tend to focus on gendered aspects of it and thus erase autistic women who do not fit into society's standard stereotype of autism. The media is very powerful in cementing or challenging stereotypes (Kehinde *et al*, 2021). Therefore, the media either

needs to change the portrayals of autism it presents, or society needs to recognise that media portrayals may not be wholly accurate and to critically evaluate how relatable they are to 'real-life' autistic people.

Concluding thoughts

In conclusion, in this chapter I have briefly considered some influences on how autistic women are perceived, such as those from autism theory and media stereotypes. Ultimately, this erasure of autistic women in societal discourse could contribute to continuous gendered negative portrayals against autistic women (Rohmer & Louvet, 2012). This lack of representation of autistic women ensures that there are few positive role models in popular media and could fuel further negative stereotypes towards autistic women. In turn, it means that autistic women may have the additional labour of self-advocating against ideas others hold of autism which they do not feel represent them.

References

Adamson, A., & Jenson, V. (Directors). (2001). *Shrek* [film]. DreamWorks Distribution.

Alice, J., & Ellis, K. (2021). Subverting the Monster: Reading Shrek as a Disability Fairy Tale. *Media/ Culture Journal*, **24**(5). https://doi.org/10.5204/mcj.2828

Asperger, H. (1944). Die autistischen psychopathen im kindersalter. *Archly fur Psychiatrie und Nervenkrankheiten*, **117**, 76-136.

Aspler, J., Harding, K. D., & Cascio, M. A. (2022). Representation Matters: Race, Gender, Class, and Intersectional Representations of Autistic and Disabled Characters on Television. *Studies in Social Justice*, **16**(2). https://doi.org/10.26522/ssj.v16i2.2702

Bakare, M. O., & Munir, K. M. (2011). Autism spectrum disorders in Africa. In M-R. Mohammadi (Ed.), *A Comprehensive Book on Autism Spectrum Disorders.* (pp. 183–194). InTech.

Barnes, C. (1991). *Disabled People in Britain and Discrimination*. Hurst and Co.

Barnes, E. (2022). Gender without Gender Identity: The Case of Cognitive Disability. *Mind*, fzab086. https://doi.org/10.1093/mind/fzab086

Belcher, C., & Maich, K. (2014). Autism Spectrum Disorder in Popular Media: Storied Reflections of Societal Views. *Brock Education*, **23**(2), 97-115. https://doi.org/ 10.26522/BROCKED.V23I2.311

Bernard, L., Fox, S., Kulason, K., Phanphackdy, A., Kahle, X., Martinez, L., Praslova, L., & Smith, N. A. (2023). Not your "typical" research: Inclusion ethics in neurodiversity scholarship. *Industrial and Organizational Psychology*, **16**(1), 50-54. https://doi.org/10.1017/iop.2022.100

Black, R., Alexander, J., Chen, V., & Duarte, J. (2019). Representations of Autism in Online Harry Potter Fanfiction. *Journal of Literacy Research*, **51**(1), 30–51. https://doi. org/10.1177/1086296X18820659

Bleuler, E. (1908). Die Prognose der Dementia praecox (Schizophreniegruppe). *Allgemeine Zeitschrift für Psychiatrie und psychischgerichtliche Medizin*, **65**, 436–464.

Borsotti, V., Begel, A., & Bjørn, P. (2024). Neurodiversity and the Accessible University: Exploring Organizational Barriers, Access Labor and Opportunities for Change. *PACM on Human-Computer Interaction*, **8**(1).

Bowden, P., & Mummery, J. (2009). *Understanding Feminism.* Routledge.

Brett, D., Warnell, F., McConachie, H. & Parr, J.R. (2016). Factors affecting age at ASD diagnosis in UK: no evidence that diagnosis age has decreased between 2004 and 2014. *Journal of Autism and Developmental Disorders*, **46**(6), 1974-1984. https://dx.doi.org/10.1007/s10803-016-2716-6

Broderick, A., & Roscigno, R. (2021). Autism inc.: The autism industrial complex. *Journal of Disability Studies in Education*, **2**(1), 77–101. https://doi.org/10.1163/25888803-bja10008

Brooks, E. (2018). "Healthy Sexuality" Opposing Forces? Autism and Dating, Romance, and Sexuality in the Mainstream Media. *Canadian Journal of Disability Studies*, **7**(2), 161–186. https://doi.org/10.15353/cjds.v7i2.428

Chiarotti, F., & Venerosi, A. (2020). Epidemiology of autism spectrum disorders: A review of worldwide prevalence estimates since 2014. *Brain Sciences*, **10**(5), 274. https://doi.org/10.3390/brainsci10050274

Cook, B. & Garnett, M. (Eds.). (2018). *Spectrum Women: Walking to the Beat of Autism.* Jessica Kingsley Publishers.

Dean, M., & Nordahl-Hansen, A. (2021). A Review of Research Studying Film and Television Representations of ASD. *Review Journal of Autism and Developmental Disorders*, 1-10. https://doi.org/10.1007/s40489-021-00273-8

Fletcher-Watson, S., & Happé, F. (2019). *Autism: A new introduction to psychological theory and current debate.* Routledge.

Garland-Thomson, R. (1997). Extraordinary Bodies: Figuring Physical Disability in American Culture and Literature. Columbia University Press.

Garland-Thomson, R. (2002). Integrating Disability, Transforming Feminist Theory. *NWSA Journal* **14**(3), 1–32.

Garland-Thomson, R. (2011). Misfits: A Feminist Materialist Disability Concept. *Hypatia*, **26**(3), 591-609. doi:10.1111/j.1527-2001.2011.01206.x

Grinker, R. (2018). Who owns autism? Economics, fetishism and stakeholders. In E. Fein & C. Rios (Eds.), *Autism in translation: An intercultural conversation on autism spectrum conditions.* Palgrave MacMillan.

Hoyt, L. T., & Falconi, A. M. (2015). Puberty and perimenopause: Reproductive transitions and their implications for women's health. *Social Science and Medicine*, **132**, 103– 112. https://doi.org/10.1016/j.socscimed.2015.03.031

Janse van Rensburg, M. G. (2022). Representations of autism in Ontario Newsroom: A critical content analysis of online government press releases, media advisories, and bulletins. *Studies in Social Justice*, **16**(2), 407-428. https://doi.org/10.26522/ssj.v16i2.2664

Kanner, L. (1943). Autistic disturbances of affective contact. *Nervous Child*, **2**, 217–250. Retrieved from www.docdroid.net/h6HnfGv/kanner-autistic-disturbances-of-affective-contact-1943-vooiwn-pdf (accessed July 2024)

Lloyd, M. (2001). The Politics of Disability and Feminism: Discord or Synthesis? *Sociology* **35**(3), 715–28. https://doi.org/10.1017/S0038038501000360

Loftis, S. F. (2021). The Metanarrative of Autism: Eternal Childhood and the Failure of Cure. In D. Bolt (Ed.), *Metanarratives of Disability.* (pp. 94–105). Routledge.

Loomes, R., Hull, L., & Mandy, W. P. L. (2017). What is the male-to female ratio in autism spectrum disorder? A systematic review and meta-analysis. *Journal of the American Academy of Child & Adolescent Psychiatry*, **56**(6), 466–474.

Lorre, C., & Prady, B. (Creators). (2007-2019). *The Big Bang Theory* [Television Series]. Warner Home Video.

Matthews, M. (2019). Why Sheldon Cooper can't be black: The visual rhetoric of autism and ethnicity. *Journal of Literacy & Cultural Disability Studies*, **13**(1), 57-74. https://doi.org/10.3828/jlcds.2019.4

Mattila, M. L., Kielinen, M., Linna, S. L., Jussila, K., Ebeling, H., Bloigu, R., et al (2011). Autism spectrum disorders according to DSM-IVTR and comparison with DSM-5 draft criteria: an epidemiological study. *Journal of the American Academy of Child & Adolescent Psychiatry*, **50**(6), 583–592.

McGuire, A. (2016). *War on Autism*. University of Michigan Press.

McKinney, C. (2014). Cripping the Classroom: Disability as a Teaching Method in the Humanities. *Transformations: The Journal of Inclusive Scholarship and Pedagogy* **25**(2), 114–27. https://doi. org/10.5325/trajincschped.25.2.0114

Milner, V., McIntosh, H., Colvert, E., & Happé, F. (2019). A qualitative exploration of the female experience of autism spectrum disorder (ASD). *Journal of Autism and Developmental Disorders*, **49**(6), 2389–2402. https://doi. org/10.1007/s10803-019-03906-4

Milton, D. E. (2014). Autistic expertise: A critical reflection on the production of knowledge in autism studies. *Autism*, **18**(7), 794–802. https://doi.org/10.1177/1362361314525281

Moore, I., Morgan, G., Welham, A., & Russell, G. (2022). The intersection of autism and gender in the negotiation of identity: A systematic review and metasynthesis. *Feminism & Psychology*, **1-22**. https://doi.org/10.1177/09593535221074806

Moriarty, S. (2021). Modelling Environmental Heroes in Literature for Children: Stories of Youth Climate Activist Greta Thunberg. *The Lion and the Unicorn* **45**(2), 192-210. https://doi.org/10.1353/ uni.2021.0015.

Morris, J. (1993). Feminism and Disability. *Feminist Review*, **43**, 57-70. https://doi.org/10.1057/ fr.1993.4

Morris, J. (1996). *Encounters with Strangers: Feminism and Disability*. The Women's Press.

Morris, M. (1998). Feminism, reading, postmodernism. In J. Storey (ed.), *Cultural Theory and Popular Culture: A Reader* (2nd ed.). (pp. 365–370). Prentice Hall.

Murray, S. (2008). Representing Autism: Culture, Narrative, Fascination. Liverpool University Press.

Price, M. (2015). The Bodymind Problem and the Possibilities of Pain. *Hypatia*, **30**(1), 268-284. doi:10.1111/hypa.12127

Ressa, T. W., & Goldstein, A. (2021). Autism in the Movies: Stereotypes and Their Effects on Neurodiverse Communities. *Journal of Disability Studies*, **7**(2), 55-64. www.pubs.iscience.in/ journal/index.php/jds/article/view/1197 (accessed July 2024)

Rohmer, O., & Louvet, E. (2012). Implicit measures of the stereotype content associated with disability. *British Journal of Social Psychology*, **51**(4), 732–740. https://doi.org/10.1111/j.2044–8309.2011.02087.x

Ryalls, E. D. & Mazzarella, S. R. (2021). "Famous, Beloved, Reviled, Respected, Feared, Celebrated:" Media Construction of Greta Thunberg. *Communication, Culture and Critique*, **14**(3), 438–453. https://doi.org/10.1093/ccc/tcab006

Schalk, S. (2016). Reevaluating the supercrip. *Journal of Literary & Cultural Disability Studies*, **10**(1), 71-86. https://doi.org/10.3828/jlcds.2016.5

Seers, K., & Hogg, R. (2021). 'You don't look autistic': A qualitative exploration of women's experiences of being the 'autistic other'. *Autism*, **25**(6) 1553–1564. https://doi. org/10.1177/1362361321993722

Serra, M. L. (2015). Feminism and Women with Disabilities. *The Age of Human Rights Journal*, **5**. 98-119.

Simplican, Stacy Clifford. (2017). Feminist Disability Studies as Methodology: Life-writing and the Abled/disabled Binary. *Feminist Review*, **115**(1), 46–60. https://doi.org/10.1057/s41305-017- 0039-x

Smale, H. (2013) *Geek Girl*. Harper Collins.

Spies, M. (2021). From Belonging as Supercrip to Misfitting as Crip: Journeying through Seminary. *Journal of Disability & Religion*, **25**(3), 296-311. https://doi.org/10.1080/23312521.2021.1895028

Stenning A. (2022). Misfits and ecological saints: strategies for non-normative living in autistic life writing. *Disability studies quarterly*, **42**(1), dsq.v42i1.7715. https://doi.org/10.18061/dsq.v42i1.7715

Thomas, C. (2006). Disability and gender: reflections on theory and research. *Scandinavian Journal of Disability Research*, **8**(2-3), 177–185. https://doi.org/10.1080/15017410600731368

Townson, R., & Povey, C. (2019). Run the world, girls: Success as an adult autistic female. In B. Carpenter, F. Happé & J. Egerton (Eds.), *Girls and Autism*. (pp. 171-178). Routledge.

Wing, L., Gould, J. (1979). Severe impairments of social interaction and associated abnormalities in children: Epidemiology and classification. *Journal of Autism and Developmental Disorders*, **9**, 11–29. https://doi.org/10.1007/BF01531288

Woods, R., Milton, D., Arnold, L. & Graby, S. (2018). Redefining Critical Autism Studies: a more inclusive interpretation, *Disability & Society*, **33**(6), 974-979. https://doi.org/10.1080/09687599.2018.1454380

Chapter 3:

The challenges of working while studying

While studying as a postgraduate student, particularly when studying a postgraduate research course such as a PhD, it is common to undertake some sort of part-time paid work within academia, such as teaching, marking or working as a research assistant. This may be for a range of reasons, such as to gain experience in the sector and/or to fund studying. Paid work may require working with different people in different professional contexts in which students become staff or hold other positions of responsibility. An individual may therefore be both a student and a member of staff at the same university.

In the academic year 2021-2022, 1,035 postgraduate female students and 70 students who categorised themselves under 'other gender' declared that they were autistic (Higher Education and Statistics Agency, 2023). It is important to remember that students who disclose two or more disability labels are classified in a separate category. In addition, some students may either not have a formal diagnosis (so cannot be included in the statistics) or choose not to disclose. These statistics therefore give an indication, but not a definitive number, of how many autistic postgraduate students are at university in the UK. Considering these indicative numbers, it is important to reflect on how autistic postgraduate women may navigate studying in combination with paid work. O'Brien (2023) highlights how education (with the right support) can be one of the most supported environments for autistic people, and therefore may be an environment in which an autistic student wants to remain after

studying. Although academia may feel safe for autistic people, they can face many barriers and challenges, as in other workplaces. For example, in academia, autistic women may be subject to a 'double disadvantage' where societal stigma towards both gender and autism intersect, to create more barriers than somebody who only has one minority identity. This is not to say that autistic women do not have other intersectionalities that can add further barriers to navigate, but they are starting from a point of at least two intersectionalities that together likely provide more disadvantage than a neurotypical woman may experience (Nagib & Wilton, 2020). Autistic women may therefore have to navigate the employment landscape in academia with more care and awareness than a neurotypical academic.

The underemployment and difficulties that autistic people may face in employment have recently become a popular topic in research, with the aims of improving the prospects of autistic adults and benefitting the wider economy. Autistic graduates are repeatedly reported to have poor employment outcomes (Association of Graduate Careers Advisory Services (AGCAS), 2024). Specifically, for autistic women, employers may not understand the heterogeneity of autism, particularly in relation to autistic women, and therefore unsure of adjustments and changes that can be made to the workplace environment (North, 2023). Finding out what is needed in order to include autistic women may be time consuming and require additional labour, and therefore be off putting to employers.

In order to mitigate some barriers to employment, support may be sought. However, this can pose challenges as the support available for staff and students may differ – even if a person is a student and a staff member in the same institution. Seeking support as an employee is different to seeking support as a student. At university, being a disabled student may be seen as being advantageous, because universities may be keen to attract disabled students to increase favourable statistics about inclusivity. Although it may need increasing, some funding in academia is ringfenced for students from minority groups, which includes disability (where neurodiversity is classified). It may therefore be in the university's best interests to recruit disabled students, particularly into postgraduate courses where they are traditionally under-represented (Gibson *et al*, 2023). Disabled students may then be able to access support and reduce barriers to study. However, when an individual is a staff member, they may not be afforded the same privileged status as a student as they turn from consumer to producer and they become part of the marketisation of higher education.

In this chapter, I draw on both my own experiences of teaching while studying at postgraduate level, and the experiences of some of the participants in my PhD research. I focus on the experiences of two participants – Cassy and Sarah – who held roles as both postgraduate students and another position of responsibility. Cassy studied alongside being a member of the academic staff at her university, and Sarah was both a student and a trainee school teacher. They spoke about and implied notable differences in how they felt in both roles. Conversations covered topics such as gatekeeping, conforming to expected norms and being afforded different privileges dependent on which role a person was in at the time. I grapple with the notion that a person is expected to change their identity and needs depending on the scenario, even if physically in the same setting.

Placements

Part of university courses often involve undertaking work placements. Sarah was undertaking a postgraduate course in teacher training, which required her to complete placements in a school. before this, she had completed a PhD. She found there was a negative attitude towards her autism when she was on placement in schools, which she had not experienced to the same degree as a student at university. At university, although she had had to self-advocate for adjustments and accommodations, Sarah felt she was generally supported and received the majority of adjustments she had asked for. Damiani and Harbour (2015) interviewed 12 disabled graduate teaching assistants in the US about their experiences of teaching as disabled graduates and reported similar feelings about the difference between being accepted as a disabled employee and as a disabled student. Results explored disability accommodations, personal identity, and where discussion about disability could take place. Most notably, they report that several of their participants were happy to disclose their disability to seek accommodations when they were in the role of a student, but as an employee did not want to for fear of others judging their capabilities. This meant that participants developed 'self-accommodations', usually deciding what things disabled them less, making compromises, and making time for extra planning. For example, one participant had to choose between a room in a building with no disabled toilets or a room without an accessible lectern, while some neurodivergent participants had to adapt by employing a copyeditor and devoting several hours to providing students verbal instead of shorter, written feedback on

assignments. Although Sarah was happy to identify as disabled at university, and went into school with the same positive attitude towards being autistic, the perception she got from the school was that she had to change her identity and hide her true self as it was not acceptable to be disabled.

> *'I use microphones, which have been brilliant. They pick out the person I'm trying to speak to from the background noise... The school clearly were kind of whoa this is a defective disabled person. They aren't colleagues, they are their special needs students, I mean that was clearly the underlying attitude. And so rather than make it so that I could attend things like staff meetings and training, they just told me not to bother.'*
>
> (Sarah)

Sarah also struggled with conformity and the expectations of not being 'allowed' to be disabled in different settings. Regarding her use of microphones to mitigate auditory difficulties distinguishing a single voice from background noise, Sarah did not feel she received a warm reception when using them. Thus, she did not know whether she was expected to hide her disability as a teacher rather than share it, or whether to try to meet expected standards without any support or adjustments. By saying she felt that she was not a colleague but rather a 'special needs student' and a 'defective disabled person', Sarah clearly felt an element of discrimination and very unsupported by the school.

The poor support Sarah received may be due to the lack of awareness about autistic staff in schools. Both Lawrence (2019) and Wood and Happé (2021) highlight that minimal research has been devoted to autistic teachers, despite much research having been focused on autistic children's education. They both document how some autistic trainee teachers have had difficult experiences, for example because of not understanding the expectations other colleagues had. Thus, in the small amount of literature that exists, Sarah's feeling of a lack of support is not uncommon, however it does not mean it should be the norm. Wood and Happé (2021), on the other hand, do say that, if autistic educators are supported and feel understood, they can be role models for autistic pupils and provide

expertise to colleagues. It may therefore be the willingness of a placement school to include an autistic trainee teacher that encourages them into the profession. A university should feel a duty to encourage schools to accept autistic students on placement, because even though it is a professional environment, the student remains a student and is entitled to support. Although Sarah undertook a placement in a school, many other university courses include placements in different professions where similar experiences may occur. A willingness by placement providers to accept and support autistic students needs to be ensured, which perhaps requires a culture change in acceptance.

In addition, it could be suggested that there is a difference between a person's role as a consumer (when they are a student) versus being an employee (while on placement). As a student, a person is a paying consumer and so the university may, and should, feel obliged to make sure their 'customer' is supported. This consumer identity may also mean a student feels more inclined and empowered to argue for the support they need. However, as an employee, the same person might feel more reluctant to ask for support, not wanting to challenge their employer for fear of repercussions.

On a more practical level, Sarah cited that communication between the school and the university was poor. She implied that the school was not prepared for her and was potentially annoyed at the university's lack of communication about her needs, further cementing the differences that are expected between the needs of disabled students and those of disabled professionals. The university did acknowledge full responsibility for the lack of discussion with the school about Sarah's needs after the event, but Sarah had lost a placement school by then.

> *'So there was an acknowledged problem on their end, and they acknowledged that it was their problem and that they really should have spoken to me over the summer. And no one really quite knows why we didn't, other than they were having a reorganisation and they think it may have fallen through the cracks.'*
>
> (Sarah)

Issues such as these are particularly important to consider because university placements may be an autistic person's first experiences of the workplace, especially in a profession in which they would potentially like to make a career. This could be significantly helped or hindered by others' communication or support. Vincent (2019) highlights that autistic students often find it difficult to transition out of university because the steps after university are usually less defined and more unknown than previous transitions, such as between different education providers. Thus, more provisions and transition support need to be given. However, university courses with placements could aid this transition for autistic people, if, in contrast to Sarah's experience, they are well thought out and supported. The lines that seem to exist between what support may be deemed appropriate for a graduate student compared to what is viewed as reasonable for an employee, professional or person on placement, need to be erased to ensure that support remains the same regardless of the role a person is currently in.

Being employed in academia alongside studying

It is common to engage in some form of employment within the university during postgraduate research courses. This may be to supplement income or to gain experience of working in academia. The literature surrounding how autistic students, especially undergraduates, experience university is growing, but the experience of autistic academics remains notably absent (Jones, 2023). This could be because autistic academics are unwilling to disclose their identity or write about their experiences. Alexander (2024) and Jones (2023) argue that there are likely many neurodivergent academics, but that they are regularly othered and so are keen to hide their experiences. There may also be a stigma around who can produce knowledge about how to support autistic academics, that it has to come from neurotypical researchers, relegating autistic academics to mere consumers of this knowledge as opposed to its producers (Jones, 2023). For this reason, I want to contribute to the experiences of autistic people in academia, as the experiences of working as an autistic person in academia while studying for a PhD have not been discussed. Some academics have explicitly written about their experiences as disabled academics. For example, Alexander (2024) has written about his experience as a dyslexic academic, Hannam-Swain (2018) and Inckle (2018) have written about

being physically disabled academics, but such writings are not common. Damiani and Harbour (2015) deem that the experiences of disabled academics are frequently only valued on disability awareness days or as part of specific campaigns. This shows non-disabled students that disabled academics are not valued, and it also fails to give disabled students role models of disabled staff they can identify with. Although Damiani and Harbour (2015) are speaking about disability more broadly, their opinions very much apply to autistic academics.

Working in academia while studying may involve both positive and negative experiences. While difficulties such as those experienced by Sarah in the previous section about placements may be common, here I draw on the positives that both I and Cassy had from working while studying as postgraduate research students. This may be seen as reductionist, and I am well aware that being employed is not usually all positive or all negative, however there is growing interest in research around increasing the numbers of autistic people being employed, and I therefore wanted to highlight how being autistic can be a strength in the workplace. I think this is particularly important considering the poor outcomes autistic graduates are reported to have with employment after university. According to the Association of Graduate Careers Advisory Services (AGCAS) (2024), based on data from the academic years 2019/2020 and 2020/2021, autistic graduates (from undergraduate, postgraduate taught and postgraduate research courses) consistently experience much lower rates of full-time employment, and unemployment tends to be higher. This was in comparison to non-disabled graduates and those with any other disability label. When autistic graduates did secure employment, they were likely to report that their qualification was not necessary for the work they were doing. AGCAS compiled a similar report in 2018, noting similarly poor outcomes around employment for autistic graduates at any level. Then they also reported that the unemployment of autistic graduates increased with increasing qualification level, meaning that an autistic person with a PhD was less likely to be employed compared to an autistic person with an undergraduate degree. It appears there has been minimal change for autistic graduates between these reports. These reports of course just highlight statistics, and they do not provide any insight into the actual issues autistic graduates may be facing with regard to employment. Part of changing these outcomes may be to showcase positive experiences of employment for autistic people that makes use of their qualifications.

Entering employment may present challenges, which an autistic person has to navigate before even being able to attempt the job. Recruitment practices are traditionally based on neurotypical expectations such as requiring interviews, including maintaining eye contact and providing long, detailed answers (Martin, 2021). If a PhD researcher is applying to work in the same institution, or even the same department, where they are studying, it might be assumed that academic staff they know might be recruiting them. Despite this, it is likely that, in order to ensure fairness and equity to all candidates, personal adjustments will not be made. However, this can mean that undertaking interviews is very difficult, as they include assumptions that may not be immediately obvious, particularly to autistic people. Throughout my postgraduate studies, I applied for jobs, both to complete alongside my course and for after graduation, mainly at the same university at which I was studying. If the job did not require an interview, more often than not I was able to display that I had the skills in writing and therefore was either employed or came close. When the recruitment process required an interview, I was seldom successful. Academia is competitive and I did not therefore expect to get every job I applied for, but I believe there was an additional reason why I struggled so much. After several interviews from which I received little feedback and assumed I was doing ok, an interviewer told me that although questions may be posed in such a way that do not ask for personal examples, I should give an example of a situation where I have implemented the topic of the question. This advice completely changed how I engaged with interviews and felt revolutionary. I passed this information on to some of my friends, who enlightened me that this was a well-known fact about interviews. I felt silly that I did not know this and unsure how my academic friends just seemed to understand it. Such hidden techniques and social etiquette required in interviews are one way that autistic people are disadvantaged in securing employment, and this is before having to navigate neurotypical expectations that are frequently required in the workplace.

Cassy was employed as staff while studying her postgraduate course. She was a lecturer and was also the head of her department. Cassy had a mixed experiences of how she felt she was accepted in the workplace, although she said that these were predominately positive. She thought her autism was mostly a strength in her role as an academic member of staff, particularly when helping students work through difficult

situations. For example (see Figure 3.1), Cassy drew a picture of a pastoral meeting with a student. The image shows her sitting at the opposite end of the table from a student. There are speech bubbles above their heads. The speech bubble above the student's head contains punctuation marks to denote swearing and anger. The student has a sad expression on their face. Cassy has a thought bubble above her head with a Rubik's cube inside and has a smiling expression. There are two arrows to denote movement.

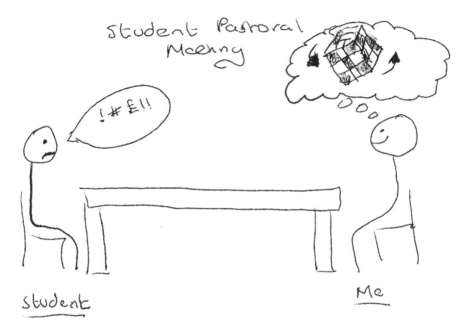

Figure 3.1: Student Pastoral Meeting, by Cassy

Using a Rubik's Cube as a metaphor, Cassy explained how she viewed students as puzzles to solve. Although likening students going through difficult situations as simply puzzles to be worked out may sound very reductionist, this pragmatic approach may allow a resolution for the student without adding additional emotional labour to Cassy.

This way of viewing her students as puzzles is also interesting to consider in terms of autism, leaving employment aside. A puzzle piece is a pervasive symbol used to depict autism. It is used to represent autism by a number of organisations (Sarrett, 2011) and appears on numerous

products of merchandise used to raise awareness of autism (Gernsbacher *et al*, 2018). Synonymy between a puzzle piece and autism awareness is ubiquitous and is argued by some (for example, Grinker & Mandell, 2015) to be one of the most well-known symbols linked to any disability or medical condition. In recent years, however, the use of a puzzle piece as a symbol of autism has attracted controversy. There are many reasons for this. Pellicano *et al* (2018) argue that jigsaw puzzles are generally associated with being children's toys and thus it has been suggested by some that linking them with autism infantilises autism. Also, the potential implication that an autistic person (the puzzle piece) needs to fit into society (the complete jigsaw) suggests to some autistic self-advocates that they are a problem needing to be fixed by other people (Pellicano *et al*, 2018; Gernsbacher *et al*, 2018). Gernsbacher *et al* (2018) conducted research into participants' views on puzzle pieces (used as an autism logo and more generically) and concluded that participants regarded it to depict incompleteness, imperfection and oddity. Despite this, using a puzzle piece as a symbol of autism awareness continues to be prominent in society. Therefore, as an autistic person, by terming her students puzzles, as opposed to herself being seen as the thing that needs to be fixed or solved, Cassy may be subverting this discourse. Cassy terms this skill 'professional empathy', suggesting she knows there is no classic description for the skills which she is using, particularly in relation to how an autistic person *should understand others*, and explains this using an example:

> '*It is not that I don't want to be sad, you know, a student comes to me with terrible situations. You know I've dealt with refugees from Syria, you know, students who had unwanted pregnancies, you know, or have been in abuse situations. And I will sit there and I will understand, in the sense I can sort of intellectually say, you know, this person is feeling sad. This person is afraid. But I very rarely feel it… In some ways that helps me with my work, because when I have students come in with terrible problems, I can deal with it sort of in a fairly calm and, I guess, rational manner.*'

> (Cassy)

In intellectually understanding the emotion but rarely feeling it herself, Cassy was able to help her students objectively. This ability may be enhanced the fact that she is currently a student herself and therefore able to understand some of the academic processes others have to navigate, and having experiences of being different through her autism. This pragmatic approach to understanding her students' difficulties with a solution-focused mindset may be of significant value to students, as her support may help them to move forward as opposed to just being able to tell somebody else in the academic sphere. This ability has also enabled Cassy to use these skills to benefit other members of staff in her department:

'I remember recently ... a colleague died. And one of my team members, in fact, she sadly committed suicide. And my dean of school came in to tell me in a class; he pulled me out of the class to tell me. And everybody was very shocked and upset. And I, I remember saying to him, "Oh, ok, well, I'm going to check her timetable, and then see if we can make sure that her classes are covered", and, you know, and I sort of acknowledged it was a shock and sad but then I just got straight into the practicalities, or we had another member of staff who died, and everybody was really shocked and upset, not in our team but on our floor. And of course I understood it was sad, but I didn't know them, and neither did everybody else, but they seemed sad. And I remember going, "Oh gosh that's a shock; that's really sad. And then. Okay, I'm going to go off and make a cup of tea".'

(Cassy)

By being able to organise the practicalities, by not being affected by emotion, she was able to give other staff space to focus on how they felt. This lack of feeling for others' emotions is usually thought of as a deficit that autistic people stereotypically have. Baron-Cohen *et al*'s (1985) well-known 'theory of mind' suggests that autistic people are unable to

empathise with others and appreciate others' views and opinions. This theory is usually explained in solely negative ways, whereas what Cassy is able to do in her phrasing of 'professional empathy' indicates how it can be used positively. Although she says she does not feel what her students are feeling, she has developed strategies to help her students without needing to feel their feelings herself. Thus, in contrast to Baron-Cohen *et al* (1985) stating that a reduction in theory of mind is a negative, in this situation, it may well be a positive and an asset to Cassy's approach.

Cassy's experience may not just be linked to autism, but rather the intersection of gender and autism. Women often complete additional labour in academia, including the roles of caring and organising, so while her reaction to the death of a colleague could be attributed to being autistic, caring for other people (in this case, the students and other staff) enough to want to sort out practicalities for them may be due to gendered expectations. I include Cassy's experiences to highlight how working in a university as an autistic woman can be a positive experience, and how it can be beneficial to those around them. She subverts the notion that autistic people's failure to empathise with other people's emotions is wholly negative, which discourse around the theory of mind in autistic people tends to suggest. It is unlikely that Cassy's students would have turned to her directly with their difficulties if they did not believe she would able to help them, nor that her colleagues would turn to her to sort out the practicalities in emotionally difficult situations. It is therefore important that non-autistic staff recognise that stereotypically 'negative' aspects of autism may in fact be beneficial in particular situations.

The specific types of jobs that students engage in may also be questioned. I have experienced some stigma in being employed outside academia while studying as a postgraduate, particularly where the job was not centred around the specific topic I wanted to go into. Anecdotally, I felt an expectation that because I was studying in academia, I should be giving something back by working there and undertaking any graduate teaching assistant and research work on offer. I think it is important to not discredit any form of employment, regardless of how it is linked to a person's course of study, especially when the statistics around autistic graduates being employed are so poor.

Autistic people may have skills that are particularly beneficial to academia, like Jones (2023) advocates. Therefore, encouraging autistic people to

apply for positions and informing them of how to conduct an interview, such as by including personal examples in every question asked, may improve their chances of employment.

Concluding thoughts

Generally, participants expressed that when they were students, they were afforded support and accommodations, but as staff members (even in the same institution) they were not. This may also be the experience in navigating the recruitment systems, particularly in interviews, to ensure they are not disadvantaged. This negotiation of identity was difficult for participants, particularly as they sometimes felt they had to hide their identity when they were a staff member because being autistic was generally considered negative. Cassy attributed being autistic as a positive in the workplace and cited qualities such as empathy and pragmatism. It should also be noted that autism may hold positive characteristics academic staff need. For example, Cassy especially felt her autism was an asset in her role as a head of department as it enabled her to be both empathetic and practical at the same time when helping students deal with problems that arose. This suggests that acceptance of autism by others is key to success, regardless of the role a person is in.

Postgraduate students may simultaneously be a student and a staff member, and their experiences and how they navigate the differences in identities cannot therefore be ignored. This is especially the case for disabled postgraduate students who may be afforded accommodations as a student they are unable to access as staff. Disability may be more understood and accepted at university due to neoliberalism and consumerism compared to in the workplace. In addition, the responses of Sarah and Cassy suggest that having more than one role while studying can be difficult due to the different personas that may need to be adopted to suit each role. Although non-autistic postgraduate students may also hold more than one role while studying (particularly those on postgraduate research courses), they may not need to hide their beliefs or other parts of their identity as much as autistic people do. Negative feelings towards dual roles could be mitigated through a cultural change towards difference, although this may be slow to be adopted.

Overall, working at university or being on placement may be an autistic person's first encounter with a workplace, and it is therefore vital to

ensure autistic people do not feel they are discriminated against from transitioning from education to work. Universities may need to look inwardly and be more alert to the support and accommodations autistic staff might need, especially if they are already a postgraduate student. This may be achieved by ensuring other staff are more accepting of autism through the provision of relevant training or peer support groups to share good practice. Further research could gather more information about autistic postgraduate students' thoughts or experiences of leaving education and transitioning into work.

References

Alexander, D. A. (2024). The dyslexic academic: uncovering the challenges faced as neurodiverse in academia and establishing a research agenda. *Disability & Society*, 1-6. https://doi.org/10.1080/096 87599.2024.2312227

Association of Graduate Careers Advisory Services. (2024). *What happens next?* www.agcas.org.uk/ latest/new-research-reports-from-agcas-and-shaw-trust-demonstrate-the-continued-impact-of-the-disability-employment-gap (accessed July 2024)

Baron-Cohen, S., Leslie, A. M., & Frith, U. (1985). Does the autistic child have a "theory of mind?" *Cognition*, **21**(1), 37-46. https://doi.org/10.1016/0010-0277(85)90022-8

Damiani, M. L., & Harbour, W. S. (2015). Being the wizard behind the curtain: Teaching experiences of graduate teaching assistants with disabilities at US universities. *Innovative Higher Education*, **40**, 399-413. https://doi.org/10.1007/s10755-015-9326-7

Gernsbacher, M. A., Raimond, A. R., Stevenson, J. L., Boston, J. S., & Harp, B. (2018). Do puzzle pieces and autism puzzle piece logos evoke negative associations? *Autism*, **22**(2), 118–125. https://doi.org/10.1177/1362361317727125

Gibson, S., Williams-Brown, Z., Shute, J., & Westander, M. (2023). Not hearing, not engaging, not happening: Elusive Inclusive HE, it is time to reconsider sector practices in partnership with disabled student expertise. *Journal of Inclusive Practice in Further and Higher Education*, **15**(1), 48-74. http://hdl.handle.net/2436/625302

Grinker, R. & Mandell, D. (2015). Notes on a puzzle piece. *Autism*, **19**(6), 643-645. https://doi.org/10.1177/1362361315589293

Hannam-Swain, S. (2018). The Additional Labour of a Disabled PhD Student. *Disability & Society*, **33**(1), 138–142. https://doi.org/10.1080/09687599.2017.1375698

Higher Education Statistics Agency. (2023, January). *Table 15 – UK domiciled student enrolments by disability and sex 2014/15 to 2021/22*. Available at: www.hesa.ac.uk/data-and-analysis/students/ whos-in-he/characteristics#breakdown (accessed July 2024)

Inckle, K. (2018). Unreasonable Adjustments: The Additional Unpaid Labour of Academics with Disabilities. *Disability & Society*, **33**(8), 1372–1376. https://doi.org/10.1080/09687599.2018.1480263

Jones, S. C. (2023). Autistics working in academia: What are the barriers and facilitators? *Autism*, **27**(3), 822-831. https://doi.org/10.1177/13623613221118158

Lawrence, C. (2019). 'I Can Be a Role Model for Autistic Pupils': Investigating the Voice of the Autistic Teacher. *Teacher Education Advancement Network Journal*, **11**(2): 50–58. https://doi.org/10.1080/09687599.2021.1916888

Martin, N. (2021). Perspectives on UK university employment from autistic researchers and lecturers. *Disability & Society*, **36**(9), 1510-1531. https://doi.org/10.1080/09687599.2020.1802579

Nagib, W., & Wilton, R. (2020). Gender Matters in Career Exploration and Job-Seeking among Adults with Autism Spectrum Disorder: Evidence from an Online Community. *Disability and Rehabilitation*, **42**(18), 2530–2541. https://doi.org/10.1080/09638288.2019.1573936.

North, G. (2023). Reconceptualising 'reasonable adjustments' for the successful employment of autistic women. Disability & Society, 38(6), 944-962. https://doi.org/10.1080/09687599.2021.1971065

O'Brien, S. (2023). *So, I'm Autistic: An Introduction to Autism for Young Adults and Late Teens.* Jessica Kingsley Publishers.

Pellicano, L., Mandy, W., Bölte, S., Stahmer, A., Lounds Taylor, J. & Mandell, D. S. (2018). A new era for autism research, and for our journal. *Autism*, **22**(2), 82-83. http://dx.doi. org/10.1177/1362361317748556

Sarrett, J. (2011). Trapped Children: Popular Images of Children with Autism in the 1960s and 2000s. *Journal of Medical Humanities*, **32**(2), 141-153. http://dx.doi.org/10.1007/s10912-010-9135-z

Wood, R., & Happé, F. (2021). What are the views and experiences of autistic teachers? Findings from an online survey in the UK. *Disability & Society*, 1-26. https://doi.org/10.1080/09687599.2021 .1916888

Vincent, J. (2019). It's the fear of the unknown: Transition from higher education for young autistic adults. *Autism*, **23**(6), 1575–1585. https://doi.org/10.1177/1362361318822498

Chapter 4:

Being an autistic autism researcher

The amount of research in the field of autism produced by openly autistic researchers is growing, which could help autistic people and contribute to a more rounded body of research (Jones, 2021). Despite this positivity, there are challenges to being an autistic autism researcher. As discussed previously, society in general, including people in academic settings, can hold stigmatised views about autistic people. In academia, it has long been debated whether a researcher should be part of the community they are researching (Dwyer & Buckle, 2009). Although this debate is more nuanced than whether a researcher fits into one of two mutually exclusive categories (being in or out of the researched community), it is still a matter that requires consideration. The debate about who should be allowed to research which communities can be complicated when relating to autistic researchers.

This chapter focuses on autistic autism researchers and the experiences they may encounter. However, I do not mean to exclude non-autistic autism researchers or neglect the fact that every researcher has many intersectional parts of their identity, of which autism may only be one. I artificially draw attention to the debate of the autistic versus non-autistic researcher to highlight how autism specifically may impact experiences in the autism research field. It could help to be armed with an understanding of the challenges and benefits that an autistic researcher may encounter when beginning research. Most importantly, I draw attention to the fact

that autistic researchers are likely to have to think about ways in which they can make research work for both themselves and their participants, which may result in extra labour that non-autistic researchers do not need to engage with.

I hope that this chapter can provide an overview of the considerations and barriers that an autistic autism researcher may face, both for autistic people entering the field, and so that others in academia are aware of extra issues that they themselves may not need to consider.

Some cautions of being an autistic autism researcher

An experience may not be wholly positive or negative, and the lines are sometimes blurred. I discuss three areas: researching to support my own needs; verifying 'real' participants; and tokenism, which autistic researchers may wish to caution themselves against. I also emphasise these topics to ensure non-autistic researchers are explicitly aware of the impact they may have on autistic researchers, particularly in the field of autism research.

Researching to support my needs

When conducting research, ethical procedures must consider the needs of the participants. Researchers tend to have to justify how they will not harm the participants and ensure the project is accessible for the target sample, however, the accommodations that a researcher might require are rarely considered (Kerschbaum & Price, 2017). I did not think I could undertake my research without thinking about my own needs and limitations. Kerschbaum and Price (2017) suggest that this is because, while participants can be portrayed as non-normative, researchers cannot. Of course, some participants may still not be afforded all the ethical protection they should have, but their wellbeing during research studies is certainly considered more widely than that of the researcher.

A researcher who does not need to consider any adaptations may be particularly privileged in the research sphere. Chouinard (2020) is a disabled researcher who argues that having an able body and mind in academia is a privilege, particularly when it comes to conducting research in the 'field'. She notes that the pressure of conforming to academic practices and norms can lead scholars to become disabled, especially in terms of their mental health. It is therefore important to consider

how research can accommodate researchers and not be constrained by currently accepted normative practice. This may mean setting boundaries on the times of data collection, for example, to accommodate childcare, or communicating in ways that suit the researcher. Particularly during data collection, a careful balance may need to be struck between participants and researchers to ensure ways of working that suit all involved.

For my PhD research project, I decided to conduct all data collection online so that I would not have to travel to see participants. I was hoping to gain participants from all over the UK, and therefore would have had to travel around the country to interview them. I did not feel comfortable travelling to unfamiliar places that were potentially very far away (besides the cost). I also asked participants to create artefacts, some of which feature in other chapters of this book. This was to allow the participant to communicate in creative ways of their choice, with only the broad brief of documenting their experiences at university and how they felt their autism had impacted them (either positively or negatively). Although I was able to sell this as a way to support the participants, it was also to give me something to focus on in the interviews, to help me remain on track and to provide a common focus for discussion between me and the participant.

The verifying of 'real' participants

Recently, focus in the field of autism research begun considering the validity of participants, particularly working out whether individuals participating online are actually 'scammers', meaning they are completing the research – usually for financial gain – without being part of the target group (Pellicano *et al*, 2024). Using online methods for qualitive research have become much more popular, particularly since the Covid-19 pandemic, to increase inclusivity (Pullen Sansfaçon *et al*, 2024).

Using online methods may be more common for disabled or, specifically, autistic researchers, to accommodate their needs. It may be much easier online for participants to be dishonest about their identity and to find plausible answers (such as by using search engines) to qualitative research questions. Pellicano *et al* (2024) highlight that it is difficult to ensure that research is as inclusive as possible while making sure the data gained is of high quality. This is interesting, particularly as self-identification of autism has become more accepted. Therefore, I wonder if a foolproof method of screening autistic participants to check their validity will ever be possible, although it is likely that researchers will need to adapt how they conduct

online research. In addition, this new focus on establishing the veracity of autistic participants (which may be at odds with self-identification) could be extended to more questioning around the identity of researchers, particularly to those who are autistic. This may or may not be harmful to autistic researchers, depending upon how their 'realness' is determined. Consequently, careful consideration of how identity verification in research is conducted is paramount to ensure 'real' autistic participants and, by extension, that real autistic researchers are not excluded from the field.

Overall, an individual autistic researcher may not have any negative experiences, or they may encounter different experiences from those that I have discussed. However, it is important to consider whether there are times or situations where an autistic researcher, or by extension autistic participants, might be more vulnerable to mistreatment.

Tokenism

In research, tokenism is a term that can refer to the inclusion of something or someone to satisfy certain requirements, rather than to genuinely enhance a project. For example, in the context of autism research this might be a group of non-autistic researchers including an autistic researcher in their project team, but not listening to their opinions or only involving them on a very superficial level. Fletcher-Watson *et al* (2018) argue that tokenism is better than being excluded from research entirely, for example by simply receiving the outcome of research, however being full partners in research and therefore being able to influence decisions is better and more meaningful than tokenism.

In an ideal world, the tokenistic use of autistic researchers and partners in projects would not occur, and genuine collaborations that share power remain rare (Pellicano *et al*, 2022). Some research is slowly moving towards either being led by autistic researchers or to properly including autistic researchers in a participatory manner. Some non-autistic researchers (for example, Thompson-Hodgetts, 2022) now highlight the importance of being reflexive about their own identity and work practices, so that they can make their research more inclusive of the lived experiences of autistic people. This can include listening to autistic researchers, undertaking co-produced research and ensuring autistic people are meaningfully included in all stages of the research process. In addition, some autism research journals (such as *Autism* and *Autism in Adulthood*) are now asking for authors of articles to justify how autistic people were involved in the

research process and the authors' positionality in relation to autism. It is, however, still important to guard against tokenism, particularly when starting out in academia, and autistic people are vulnerable to it when wanting to be involved in research projects to gain experience.

A sticky situation I ended up in was participating in a project run by a team that included autistic co-researchers and academics. Some of the autistic co-researchers were fledgling academics and some were lay people. The aim was to ensure the research was shaped by both autistic and non-autistic voices, with a variety of academic backgrounds at all stages, including dissemination. Team meetings were inclusive and seemed collaborative. As the research progressed, we were asked to collaborate on a journal article and received formal invitations and confirmations of author status from a journal. Some of us who were autistic academics starting out in postgraduate study were excited by the prospect of being part of a journal article, in a field we were interested in entering. Unfortunately, when it was published, all of the names of the autistic collaborators as authors had been removed by the lead researcher. This was disappointing and felt like we 'had been used' purely for our status as autistic people. Some of us mounted a challenge to this with the journal and the decision was thankfully overturned. I felt I had been naïve in assuming that academic promises would be honoured. Although as I have briefly discussed, tokenism may be reducing in autism research, this experience has made me feel weary about collaborative research. I think it is therefore important to build up trust with the other researchers on a research team, and to agree clear outcomes for the research at the earliest opportunity.

The potential benefits of being an autistic autism researcher

So far in this chapter, I have primarily focused on the negative aspects and additional work that can come with being an autism researcher who is autistic. The potential advantage of being autistic in both the autism research field and beyond is much less frequently discussed. Kara (2020) explains that the subject of autism research has traditionally been a deficit or problem that it is seeking to mitigate or solve. The idea of exploring anything from a positive perspective, including identity, is therefore a newer concept. It is important to discuss autistic strengths in research

contexts, both to counteract any narratives surrounding being autistic and to ensure autistic researchers harness their abilities and their own experiences to contribute to the research field.

The autistic advantage in research

Autistic researchers may have certain advantages in research due to the characteristics of autism. Autistic people have many skills that could enhance the research process, although these are not often documented in the literature. Grant and Kara (2021) are a notable exception, discussing how elements of their autistic identity have been particularly beneficial when working in qualitative research teams, such as their hyper-focus, creative thinking and attention to detail. Hyper-focus may mean the ability to concentrate on a task for a long period of time and/or in a very productive manner. They acknowledge, however, that their ability to perform is based on context and other people's willingness to accept them. Sometimes the systems that rule academia also mean that autistic advantages cannot be used, for example a PhD thesis may have to be presented as a written document to pass academic tests of rigour.

Writing research and reading literature requires a high level of focus and interest in academia. Autistic people are documented to enjoy talking about things they are particularly interested in, which is sometimes considered to signal a lack of understanding of typically accepted social cues and the back and forth of mutual conversation (Morgan-Trimmer, 2022). Special interests[4] within autism do not receive much positivity because they are often seen as obsessions, and that they control a person's ability to do other things. If a person's area of interest is what they are researching, however, they may be able to focus on it intensely without being distracted, and this could therefore be a huge benefit. This passion may be needed for academia to ensure research is beneficial and progressive. Thus, although some characteristics of autism can be seen as negative or unhelpful in certain situations, if the environment and situation for autistic people are right (not just in academia), then monotropism may be an extremely positive asset (Grove *et al*, 2018).

Autism as a singular label is attributed to people with widely different needs, strengths and difficulties. While there may be many barriers against being an autistic researcher, it should be acknowledged that to

4 This is also described as monotropism, when a person focuses on a few interests rather than several at a time (Murray, 2018).

be autistic and be able to conduct research is a privilege in itself. Autistic researchers themselves have navigated how to conduct research. It must be acknowledged that there are huge numbers of autistic people who are seldom included in research but who should be, such as autistic people who do not communicate via speaking. More widely, Arstein-Kerslake *et al* (2020) argue that, despite disability research advocating for 50 years for equality, disabled people are frequently the *subject* of research rather than being part of it, as researchers or co-researchers. Therefore, being an autistic researcher and being able to do research rather than being its subject is an immense privilege. It is therefore important to remember the strengths autistic autism researchers have, which they may be able to use to benefit the wider autism community, even if the environment is not always conducive to them.

Exposing my own autistic identity as a researcher

Feeling comfortable talking about part of an identity that can be hidden, or is not immediately obvious to other people, is a privilege. It requires self-confidence and trust in how other people will react to that disclosure and that negativity will not occur. When I started applying for PhD research funding, I decided to be transparent about my own identity as an autistic researcher who wanted research within the field of autism. I had been formally diagnosed with autism two years before I started applying and felt confident in my identity. However, I had not appreciated that other academics did not feel the same way. In one interview for a funded PhD, the panel focused on how researching people with whom I shared elements of my identity would create bias in the research. My argument was that all qualitative research has elements of subjectivity and therefore as long as I declared my own positionality and beliefs, my own identity is simply part of my research project rather than having a positive or negative impact. However, they decided that I was unable to objectively research the population due to being a member of it. Unsurprisingly, I did not receive an offer from that university. There is a growing focus on ensuring that research teams exploring autism include autistic people, and so this experience – which took place about five years ago – may have had a different outcome today. At the time, however, this was demoralising, particularly as I was unsure whether other academics would hold similar opinions. But I was determined to

get into academia, and ultimately, after two years, I received a funded PhD offer where my supervisors did not view my being an autistic person to be negative. Botha (2021) (an autistic academic) was similarly discredited for researching autism as an autistic person. They were approached while presenting a poster at a conference by a delegate who asked them about their research, and on disclosure of their identity, the delegate explained that they were unsure that an autistic person should be researching autism. Botha's (2021) experience shows that the way in which I was questioned by non-autistic researchers was not an isolated occurrence and it is likely that, despite the shift towards including autistic people in research, autistic researchers in the field of autism may still receive criticism and scepticism about their identity. My experience of feeling rejected because of other people's opinions towards my ability to be objective and to not include my identity in research has stayed with me, and made me decide that, if possible, I do not want to work or research in an environment that is not accepting of me. I may of course not have that choice throughout my life – needing a job is ultimately, and sadly, more important, however it remains a significant value of mine.

In my PhD study, I advertised on my participant recruitment poster that I am an autistic woman. I was looking to recruit autistic women who were studying at a university in the UK. Some participants commented that they would not have taken part if I had been a non-autistic researcher, due to bad experiences they had had in the past taking part in research conducted by non-autistic researchers. While I think it is important to acknowledge that a researcher (regardless of whether they are autistic) has many strands to their identity, it is interesting that some of the participants in my study were drawn to that element of mine. My experiences are similar to those of Pellicano *et al* (2022), who conducted research into 25 late-diagnosed autistic adults and their experiences. They were also interested in how participants felt talking about themselves to an autistic researcher. They found that participants felt understood and listened because the researcher was able to be genuinely empathetic towards them, due to mutual understanding. Pellicano *et al* (2022) term this ability 'epistemic privilege' – tapping into a worldview that resonates with the participant – and view it as an advantage in this type of research. They do caveat their opinion – that autistic researchers have an advantage – by suggesting that every researcher brings intersectionalities and their own experiences which may make

participants feel more or less comfortable in research. However, it does suggest that including people in the research team with lived experiences of the research focus can be beneficial. It is interesting to note that, while a participant may feel more comfortable speaking to an autistic researcher, as Pellicano *et al* (2022) suggest, it could put pressure on an autistic participant to go into more detail and disclose more intimate things than they would have otherwise (Botha *et al*, 2022). Including information about positionality to potential participants may therefore have positive benefits, but it is also important to consider that there may be negative implications, and to take into account the ways in which they could be managed when dealing with sensitive topics.

Being transparent in research, and acknowledging how my intersectionalities fed into the project, meant more than just informing my participants that I am autistic. Hayfield and Huxley (2015) argue that researchers should not solely focus on how their identity impacts data collection, but also to concentrate on how their identity may influence data interpretation and analysis. I was very keen to not apologise for my autism in my data analysis, and so clearly stated that my data analysis was through the lens of an autistic woman. I am very aware that my data may have been interpreted differently by a non-autistic researcher, or even by a team of people that included both autistic and non-autistic researchers. This idea could be extended to any researcher revealing their own identity and intersectionalities. However, considering the negative stereotypes society places on autistic people around the interpretation of others' intentions and opinions, such as through theory of mind, it feels important to justify.

Overall, exposing my own identity and incorporating it into my research, rather than apologising for it, was beneficial in recruiting participants and helping them to share their stories. However, sharing part of my identity (which I could have hidden) was a difficult decision, particularly after my initial, poor experience when applying for a PhD. While acceptance of autism may be changing, making a conscious choice to publicly display one's autistic identity while conducting research in this area may remain politically contentious.

Navigating the autism research community

Being part of a community may be a choice, or it may be the result of part of one's identity. Entering and existing in a community may be tricky things to navigate due to complexities around behaviour and culture, but it can also be beneficial. For autistic women, who may feel excluded from autism discourse in general due to its reliance on stereotypes and masculinity, being part of a community of autistic women may enable a sense of inclusion. However, feeling part of the autistic community is not an automatic experience following an autism diagnosis. Zener (2019) highlights that it may mean different things depending on whether they sought their own diagnosis or have been encouraged by others to get diagnosed. Zener also suggests that autistic women who seek a diagnosis to confirm their own suspicions about their identity reach out to join autistic women communities online, whereas autistic women who do not think they are autistic before their diagnosis do not. This may mean that people process and internalise how autism affects their own identity differently. It also highlights that autistic people may exercise the choice to join a community following their diagnosis. In addition, Harmens *et al* (2022) state that while finding communities of autistic people can be important for autistic women after diagnosis, they emphasise that autistic women can face exclusion from both inside and outside the autistic community for not fitting stereotypes of autistic women. The same societal stigmas can be reflected in autistic community groups and therefore other autistic people may not accept other autistic people based on their identity.

Apart from choosing to belong, a person may actively choose not to belong to a certain community. Pesonen *et al* (2020) explored the perceptions of belonging of 11 autistic university students in the Netherlands. Primarily they argue that 'the construction of autistic students' belonging is not simply an individual phenomenon but a political one' (p14), and belonging therefore has a performative element to it based on accepted norms. Pesonen *et al* (2020) argue that place is always embodied and the physical environment affects whether and how a person feels they belong. They highlight that how an autistic individual experiences a place may be different to a non-autistic person, and therefore whether they feel they belong in that space may be different. Pesonen *et al* (2020) explain that autistic students actively choose whether to belong or not in different situations at university, indicating agency that may be distinct from non-autistic students. They go on to argue that choosing not to belong may

be 'productive non-belonging', in that choosing not to go to a place they feel they do not belong as their true self, spurred by exclusive internalised discourses, is more productive in other ways. Non-belonging emphasises how belonging is politicised, and universities should create spaces and environments in which all students feel they can belong without having to conceal who they are.

On X (formerly Twitter), Bluesky, Facebook and other social media platforms, there are growing communities of autistic and more widely neurodivergent researchers, some of whom are researching in the field of autism. These communities can provide a positive route to meeting others who are grappling with similar identity-based or research challenges. In addition, they can help to inform and transform autism research. Tan (2023) (a non-autistic researcher) highlights that the autistic community, including autistic researchers, challenge ideas about the topics autistic people want to be researched, which provides an opportunity for reflection about how to create meaningful research. Therefore, engaging in such discussions as an autistic researcher can be personally beneficial but can also contribute towards wider research priorities. I have enjoyed engaging with X, particularly during conferences, as it has allowed me to connect with other autistic researchers online before sometimes speaking to them in person. It has also enabled me to find other autistic people in academia, and enabled me to see that some experiences are shared. Online platforms, particularly X, may be ways to connect with and learn from other autistic women researchers.

Autistic researchers may form a community, but also autistic researchers specifically studying in the field of autism (or wider topics such as neurodiversity or disability) may come together. I think it can be quite difficult to navigate the autism research world and it is something I do not yet feel I have mastered. The vast majority of those who research autism, regardless of whether they are autistic or they have lived experience with autistic people, seem to want to both improve the lives of autistic people and progress the research field. However, thought processes around research and research priorities can vary widely between researchers. Within the autism research field, differences may be more present, particularly as autistic people have not traditionally been well-treated in research. There has been debate about who should be able to research within the field of autism. Some researchers frame their studies under Critical Autism Studies (CAS), in which the principle aim is to challenge

deficit-based thinking surrounding autism (Roscigno, 2021). Also, CAS enables research to impact the lives of autistic people by recognising the issues from society that affect them (Milton & Ryan, 2023). Despite the potential positive forward-thinking of CAS, it has troubled some autistic researchers that not all research in the field is conducted by autistic people. Woods *et al* (2018) argue for preserving a research field solely for autistic researchers and they have debated whether to create a new subsection of CAS that is only open to autistic researchers who agree with the neurodiversity movement. Guest (2020) argues that this would reduce the field rather than expand it, and produce an echo chamber only open to those who agree with this ideology, censoring others' viewpoints and ultimately restricting the field. Woods *et al* (2018) however, have decided to engage with the current field as they did not want to surrender the field to non-autistic academics. In addition, Bertilsdotter Rosqvist *et al* (2020) promoted that a new field entitled 'neurodiversity studies' should be formed to reduce research into very specific labels and instead consider neurodiversity as a whole, and this field has slowly been growing since. Researchers are continually considering new fields when they feel they are no longer welcome within existing ones, or feel a sense of community, which may or may not be reserved for chosen researchers. Rather than producing a healthy research debate, this may simply create wider rifts between researchers with different life experiences and opinions. The field of CAS is just one example where researchers may feel that they do not fit into the community. This type of 'us-and-them' feeling within a community may be amplified between autistic and non-autistic researchers due to the othering stigma and stereotypes that exist in society, which could lead to an ingrained otherness.

As a postgraduate autistic woman researcher researching autism, the landscape of research may be complicated, especially considering the tensions that exist and the misogyny that is traditionally rife in academia. As an autistic researcher in the field, I still worry that my research may be viewed as 'less' compared to non-autistic autism researchers, however my lived experience as an insider is a privileged position in the field, particularly as a new researcher wanting to make a good impression. Milton and Ryan (2023) highlight that there still seems to be a divide between autistic and non-autistic autism researchers, which they suggest is evidenced by autistic researchers tending to cite other autistic researchers, rather than being supported by non-autistic autism researchers. Tan (2023)

argues that these tensions in the autism research community can be particularly prevalent for early career researchers, and have sparked some non-autistic autism researchers to change the focus of their research. This can be a good thing, if non-autistic researchers are changing their research to better suit the needs of the autistic community, however alienating researchers based on identity is not likely to benefit anybody. It is important for autistic postgraduate researchers to still champion research by autistic and more widely neurodivergent researchers, but also to recognise and appreciate that quality research can be formed by, or with, non-autistic researchers. In sum, collaboration between autistic and non-autistic researchers, and non-academic co-researchers, may be the way to bridge some of the divides that exist in research.

Concluding thoughts

Throughout this chapter, I have considered the challenges that can be faced as an autistic autism researcher, and acknowledged of my own experiences. It important for postgraduate autistic autism researchers to have an insight into some things that may be encountered, both to be wary of the challenges they might come up against, but also to be aware that their identity can enhance their research. I highlight that, in academia, being autistic can be advantageous due to some of the skills that are usually prevalent, such as the ability to focus on a particular topic for a long period of time. There is today a slow shift towards ensuring that autistic people are more regularly included in research in meaningful ways, for example as co-researchers, as opposed to being the subject or simply recipient of research. I am hopeful that this cultural change will encompass all of academia. Overall, there is a long way to go to truly recognise the values of autistic researchers, particularly in the autism research field, however the landscape is changing.

References

Arstein-Kerslake, A., Maker, Y., Flynn, E., Ward, O., Bell, R., & Degener, T. (2020). Introducing a human rights-based disability research methodology. *Human Rights Law Review*, **20**, 412-432. https://doi.org/10.1093/hrlr/ngaa021

Bertilsdotter Rosqvist, H., Chown, N., & Stenning, A. (Eds.) (2020). *Neurodiversity studies: A new critical paradigm*. Routledge.

Botha, M. (2021). Academic, activist, or advocate? Angry, entangled, and emerging: A critical reflection on autism knowledge production. *Frontiers in Psychology*, **12**, 727542. https://doi.org/10.3389/fpsyg.2021.727542

Botha, M., Dibb, B., & Frost, D. M. (2022). "Autism is me": an investigation of how autistic individuals make sense of autism and stigma. *Disability & Society*, **37**(3), 427-453. https://doi.org/1 0.1080/09687599.2020.1822782

Chouinard, V. (2020). 'On the outside looking in?: Reflections on being a disabled social and feminist researcher', in C. Burke & B. Byrne (eds.), *Social Research and Disability: Developing Inclusive Research Spaces for Disabled Researchers*. Routledge.

Dwyer, C. S., & Buckle, J. L. (2009). The space between: On being an insider-outsider in qualitative research. *International Journal of Qualitative Methods*, **8**(1), 54-63. https://doi. org/10.1177/160940690900800105

Fletcher-Watson, S., Adams, J., Brook, K., Charman, T., Crane, L., Cusack, J., Leekam, S., Milton, D., Parr, J. R., & Pellicano, E. (2019). Making the future together: Shaping autism research through meaningful participation. *Autism*, **23**(4), 943-953. https://doi.org/10.1177/1362361318786721

Grant, A., & Kara, H. (2021). Considering the Autistic advantage in qualitative research: the strengths of Autistic researchers. *Contemporary Social Science*, **16**(5), 589-603. https://doi.org/10.10 80/21582041.2021.1998589

Grove, R., Hoekstra, R.A., Wierda, M., & Begeer, S. (2018). Special interests and subjective wellbeing in autistic adults. *Autism Research*, **11**, 766-775. https://doi.org/10.1002/aur.1931

Guest, E. (2020). Autism from different points of view: two sides of the same coin. *Disability & Society*, **35**(1), 156-162. https://doi.org/10.1080/09687599.2019.1596199

Harmens, M., Sedgewick, F., & Hobson, H. (2022). The Quest for Acceptance: A Blog-Based Study of Autistic Women's Experiences and Well-Being During Autism Identification and Diagnosis. *Autism in Adulthood*, **4**(1), 42-51. http://doi.org/10.1089/aut.2021.0016

Hayfield, N. & Huxley, C. (2015). Insider and Outsider Perspectives: Reflections on Researcher Identities in Research with Lesbian and Bisexual Women. *Qualitative Research in Psychology*, **12**(2), 91-106. https://doi.org/10.1080/14780887.2014.918224

Jones, S. (2021). Let's talk about autistic autism researchers. *Autism in Adulthood*, **3**(3), 206-208. https://doi.org/10.1089/aut.2021.29012.scj

Kara, H. (2020). *Creative research methods: A practical guide*. Policy Press.

Kerschbaum, S. & Price, M. (2017). Centring Disability in Qualitative Interviewing. *Research in the Teaching of English*, **52**(1), 98-107.

Milton, D., & Ryan, S. (Eds.). (2022). *The Routledge International Handbook of Critical Autism Studies*. Taylor & Francis.

Morgan-Trimmer, R. (2022). Autism in women – under-diagnosed, under-served and under-represented. *Murmurations: Journal of Transformative Systemic Practice*, **4**(2), 10–19. https://doi. org/10.28963/4.2.3

Murray, D. (2018). Monotropism: An interest-based account of autism. In F. R. Volkmar (Ed.), *Encyclopedia of autism spectrum disorders*. Springer.

Pellicano, E., Adams, D., Crane, L., Hollingue, C., Allen, C., Almendinger, K., Botha, M., Haar, T., Kapp, S. K., & Wheeley, E. (2024). Letter to the Editor: A possible threat to data integrity for online qualitative autism research. *Autism*, **28**(3), 786-792. https://doi.org/10.1177/13623613231174543

Pellicano, E., Lawson, W., Hall, G., Mahony, J., Lilley, R., Heyworth, M., Clapham, H., & Yudell, M. (2022). "I Knew She'd Get It, and Get Me": Participants' Perspectives of a Participatory Autism Research Project. *Autism in Adulthood*, **4**(2), 120-129. https://doi.org/10.1089/aut.2021.0039

Pesonen, H., Nieminen, J. H., Vincent, J., Waltz, M., Lahdelma, M., Syurina, E. V. & Fabri, M. (2020). A socio-political approach on autistic students' sense of belonging in higher education. *Teaching in Higher Education*, 1-19. https://doi.org/10.1080/13562517.2020.1852205

Pullen Sansfaçon, A., Gravel, E., & Gelly, M. A. (2024). Dealing With Scam in Online Qualitative Research: Strategies and Ethical Considerations. *International Journal of Qualitative Methods*, **23**. https://doi.org/10.1177/16094069231224610

Roscigno, R. (2021). Critical Autism Studies, Race, Gender, and Education. *Oxford Research Encyclopedia of Education*. https://doi.org/10.1093/acrefore/9780190264093.013.1604

Tan, D. W. (2023). Early-Career Autism Researchers Are Shifting Their Research Directions: Tragedy or Opportunity?. *Autism in Adulthood*, **5**(3), 218-224. https://doi.org/10.1089/aut.2023.0021

Thompson-Hodgetts, S. (2023). Reflections on my experiences as a non-autistic autism researcher. *Autism*, **27**(1), 259-261. https://doi.org/10.1177/13623613221121432

Woods, R., Milton, D., Arnold, L. & Graby, S. (2018). Redefining Critical Autism Studies: a more inclusive interpretation, *Disability & Society*, **33**(6), 974-979. https://doi.org/10.1080/09687599.2018.1454380

Zener, D. (2019). Journey to diagnosis for women with autism. *Advances in autism*, **5**(1), 2-13. https://doi.org/10.1108/AIA-10-2018-0041

Chapter 5:
Navigating Conferences

Studying at postgraduate level tends to involve attending conferences and presenting research work. Donlon (2021) explains that conferences are a very important part of being an academic, as they provide opportunities to hear about new and upcoming research and to meet other researchers with similar interests. Autistic postgraduate students may experience challenges, but also joy in these situations that non-autistic students may not.

In recent years, some researchers have highlighted how conferences are not always accommodating to disabled researchers (Callus, 2017; De Picker, 2020; Gordon & Gledhill, 2018; Irish, 2020; Lindsay & Fuentes, 2022; Martin, 2020a; Martin, 2020b; Mellifont, 2021a; Mellifont, 2021b). They document that disabled academics can be disadvantaged and not able to be fully included in the conference environment due to exclusion. Irish (2020) argues that conferences are generally poor at accommodating disabled people, but argues that, while some accommodation for physical disability tends to be considered, any requests relating to any other disability are neglected. Irish suggests a variety of simple ways to ensure conferences are more inclusive of autistic people, including having more structured conversational areas or moving away from the idea that breaks should be used for networking. By not accommodating all disabled people, conferences are perpetuating the stereotype that academia is exclusive to only those who can access it. While Covid-19 has changed the way conferences are delivered (for example, by making some events of a hybrid nature) this does not automatically make them accessible. With specific regard to autism, Martin (2020b, p12) suggests that conferences

are 'profile-raising activities' that do not tend to be accessible to autistic scholars for many reasons including the social complexities required during networking. This general poorness of explicitly including autistic people's experiences at conferences is what has inspired this chapter, to add to the small amount of literature in this area.

Considering the lack of inclusion of autistic people at conferences, these types of activities may mean that an autistic researcher feels they have to mask their identity to fit in. Masking (attempting to hide one's identity to fit into a perceived norm) is particularly prevalent in autistic women and can have both benefits and drawbacks, such as when making first impressions or trying to ensure a good reputation with others (Sedgewick *et al*, 2021). Miller *et al* (2021) contend that masking is not exclusive to autistic people and may be linked with stigma, but state that autistic people report having to mask less societally accepted things compared to non-autistic people, such as sensory difficulties. It may also not be a conscious act, as the ability to mask is considered to be developmental and can occur unconsciously (Leedham *et al*, 2020). The potentially unconscious element of masking may mean autistic people place an additional internalised stigma on themselves and try to mask further, particularly in situations where they are trying to impress others such as at academic conferences. Masking (whether a person is aware they are doing it or not) can be very tiring and may lead to a reduction in self-esteem and self-confidence if the person is always trying to fit in with the conversation of others and present as a 'normal academic'. It is important to note that autistic people tend to mask in order to be *accepted* rather than *liked* by neurotypical people, and in order to follow the dominant societal narrative that behaving neurotypically is best (Pearson & Rose, 2023). There is also an argument about whether masking should be required or whether others should be accepting of the range of people that exist in academia, however until society is fully accepting of autistic people, masking will remain necessary in some situations, including at academic conferences.

In this chapter, I draw on my experiences of being an autistic postgraduate student, but also on the experiences of the participants in my PhD research. Explicitly, I draw on the artwork and words of Cassy and Katie. Cassy holds a senior role in a university department and was undertaking a PhD as part of her staff development during the research. This meant she regularly attended conferences as part of both her work and her study,

but felt they were the biggest barrier she encountered in academia due to the social requirements they demand. Katie was a final-year PhD student studying organisational psychology who had only received a formal autism diagnosis shortly before being part of my research. She felt this meant she had not had access to support she thought would have helped her navigate academia more easily. Ultimately, this chapter emphasises how the autistic postgraduate experience is holistic and can extend to academic events beyond a person's 'home' university department.

I highlight how conforming to perceived behavioural norms at a conference when networking or presenting can be emotionally draining and involves additional labour, but can also be positive because complimentary feedback can contribute to confidence. Throughout, I highlight that the culture of conferences needs to change to be more sensorily inclusive and to ensure that autistic researchers feel they belong even if they find meeting traditional norms of conference participation difficult.

Networking

Most conferences seem to have time built into them for networking, whether that is a formal session or through having long breaks and lunchtimes. Oester *et al* (2017) suggest that the benefits of conferences are not only being able to listen to presentations on research, but also the opportunity to engage in two-way conversations with others as this can build research collaborations and enhance an academic's career. They document that two-way communication tends to happen in hallways and other less-formal environments of a conference, such as over coffee, and that it is a more natural way of getting to know another person. Regardless of how it is configured, networking is likely to always be an important part of conferences, and by extension, academia. However, networking can present challenges to autistic academics, such as navigating social rules and regularly needing to meet new people at each different conference due to the transient nature of academic positions (Jones, 2023).

Unstructured networking

In my research, two participants, Cassy and Katie, describe the hardest part of attending conferences to be when they are required to network or socialise in unstructured times such as coffee breaks.

Chapter 5: Navigating Conferences

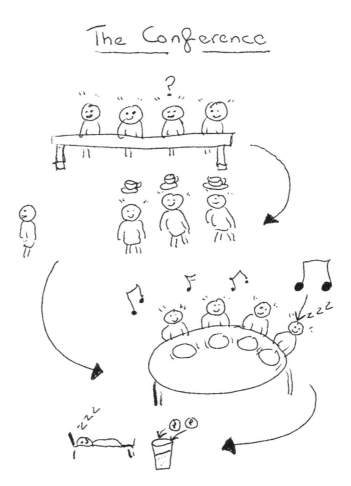

Figure 5.1: The Conference, by Cassy

Cassy created the above image that she entitled 'The Conference'. It depicts how she feels attending a conference, as four smaller images in a timeline. The first image shows her feeling happy being on a conference panel. The second image depicts her walking away from others at coffee breaks. The third image shows her tired at a conference dinner. Finally, the fourth image shows Cassy asleep with paracetamol tablets beside her. The drawing is created using a computer drawing package and only the colour black is used.

Cassy documented this experience as she felt conferences were, and continue to be, the biggest barrier to her in academia. They evoked feelings of failure as she thought everybody else wanted to be there, but

that she just wanted to be alone. Cassy also explained how the differences in expectations for different social situations at conferences made it difficult for her to attend, as she was worried about the unstructured social aspects of the conference. She was not concerned about speaking in front of large groups of people, but felt uncomfortable when having to socialise:

'When it's small gatherings, particularly things like meetings or conferences where you are expected to go off and mingle and socialise and forge links. That, for me personally, can be really quite challenging ... you know, when everybody gets together at a conference and they have cups of coffee and they talk and people sort of say that is really when you do the real networking.'

(Cassy)

She describes how the social aspects of conferences are, for her, a barrier to attending as they induce a lot of anxiety, particularly as she is fully aware that conventionally the unstructured time at conferences is where meeting people happens, which may be important for further academic success.

Katie experienced similar social difficulties when trying to network at a conference:

'We are expected to go to lots of networking events, and that's always been a challenge of mine ... you're expected to make connections with lots of different people, but I just don't know how it's really, really hard for me to do that and it's really exhausting. If I do manage to do it.'

(Katie)

Both Cassy and Katie found the expectations and conference norms of networking to be difficult and off putting. This could be because social difficulties are a stereotypical part of autism or, like Katie says, something that you are just expected to know how to do but are never

79

explicitly taught. This anxiety might be why socialising at events feels so exhausting. Throughout my PhD, I enjoyed attending conferences, mainly to hear what other people were researching in related areas. I found (and still find) networking difficult as I am not always sure how to start a conversation. At some conferences I have been to, attendees were given different coloured stickers to wear that denoted whether they were happy to initiate conversation, wanted others to initiate conversation or did not want to be spoken to. Being able to show that I wanted others to initiate conversation at one conference at the very beginning of my PhD was particularly beneficial. Another PhD researcher asked me about the topic of my research. After a short discussion about the then dearth of research about autistic university students, she said there was even less research or interest in the postgraduate autistic experience. She seemed very annoyed about this and then turned away. I never knew her name, but that short interaction highlighted that I should not restrict my research to undergraduate autistic students. I remain thankful to her for that short interaction and the knowledge I gained, and that she initiated conversation with me when I am usually excluded from networking due to the social demands and complexities I have been discussing.

Networking as a space of exclusion

Martin (2020b) says that networking in general is not typically suited to autistic social competencies and motivations, nor is small talk not linked to the conference theme. This is further supported by Farahar and Foster (2021, p205) who document from their own experiences of being autistic academics that 'networking is the dreaded academic phenomenon for many an autistic academic, as it pits all our challenges together in one place'. They explain that the challenges include sensory stimulation, routine changes, unpredictability and the requirement to socialise in conformist ways (such as by making eye contact). There is the expectation, however, that networking is engaged in as it is widely accepted as an academic norm, even if it can be exclusionary to autistic academics.

Until networking is not considered the gold standard of forming professional research links and access to jobs, it will remain a necessary part of academia. Byrne (2022) highlights that there is a hidden social curriculum at university that students are expected to pick up, rather than being taught, which autistic people may find hard to adapt to. This idea could be extrapolated to conference attendance, as there may be norms which autistic people do not pick up on. Therefore, conforming

Chapter 5: Navigating Conferences

to unknown expectations (for example about networking) can create emotional stress for autistic students, who then feel like an outsider if they are unable to conform (Cage *et al*, 2020). Cassy explicitly spoke about feeling as though she was unable to join in conversations and was therefore alienated. Although she was physically present during some periods of time associated with networking, she felt she was not actually included in the conversation. She also depicts these feelings of being an outsider in part of her artefact (see Figure 5.2) as, in the second part of the image, she is the character moving away from the other participants who have coffee cups above their heads. Cassy speaks of not knowing how to conform and be part of the networking rather than just not wanting to participate in it:

'I find it quite hard to integrate myself. I sort of feel a bit like the nerdy kid on the edge, you know, and I don't really know how to, I feel like everybody's tolerating my presence rather than being able to fit in and contribute.'

(Cassy)

Like Cassy says, this can mean autistic attendees feel isolated and unable to conform to the norm of engaging in networking. She describes feeling 'tolerated' by others rather than feeling like she is included in the general conversation. I have found that even when other academics I have known have kindly introduced me to others at a conference and then brought me into conversation, I have not always been able to carry on that networking. This has left me with feelings of guilt, particularly after others have tried to include me. I usually want to make new connections but I am not sure what to say, become anxious, and then feel that the words I want to say in my head get lost before they reach my mouth, and so I remain silent or say very little.

These feelings of isolation and exclusion within a networking environment are not exclusive to autistic academics, but feature for other non-dominant groups within academia. Waterfield *et al* (2019) explore the experiences of 11 Canadian academics who self-identified as working class or as coming from an impoverished background. They highlight that several of their participants cited conferences to be places in which they felt most

excluded in academia due to not identifying with the cultural capital and expected social norms. Oliver and Morris (2020, p765) explore how conferences can be specific places of academic 'outsider-ness', particularly for those who do not fit the dominant academic rhetoric of being a white male. They go on to suggest that upholding these norms makes it harder for an outsider to be accepted and for a marginalised academic to belong. Oliver and Morris (2020) contend that to be accepted, outsider academics must try to conform as much as possible to accepted norms, without excessively resisting boundaries. Not belonging is likely to lead to additional emotional labour due to not sharing the same culture and the dilemma of whether to accept the normalisation of disbelonging or to challenge it. People may feel a connection to others through the topics of research being discussed, but also need to feel as though they belong in other aspects, such as through shared experiences of academia.

Cassy also describes not being able to contribute to conversations during networking. It is questionable what the motivation is of other academics when networking, when they are unwilling to include her in conversation. For example, if somebody feels that they want to participate in order to meet others and learn what they do, then Cassy should be included, or whether they just want to promote their own research to others. In addition, a culture of silence exists particularly for academic women, in which men do not listen to them or allow them to otherwise participate (Aiston & Fo, 2021). The ability to network is therefore not just based on an individual's ability to converse, but rather on the willingness of other academics to accept differences and challenge their own stigma and stereotypes.

All the participants in my research describe networking at in-person conferences as a very difficult but accepted part of conferences, but the ways in which they approach networking were different. Having access to online forms of networking could be beneficial for autistic people as there is less emphasis on participant engagement and it is easier to take breaks whenever needed. Farahar and Foster (2021) acknowledge that networking online can be exhausting, but they recognise that it can be much easier than face-to-face conversations. I have found networking to be reduced as online conferences obviously do not have in-person coffee breaks and discussion can be limited depending upon how the online conference platform is set up. Participants can network in other ways, such as on social media platforms, without the need for talking in person, however it requires confidence to put one's ideas in an online space. Both Katie and

Cassy used elements of masking to get through it, particularly when the environment or other people attending make them feel uncomfortable, but they approached things in different ways. Cassy would attempt to network for a while, while feeling 'tolerated', and then make her excuses to leave, such as by saying she had a phone call she had to make, as she needed to rest without social interaction. Katie, on the other hand, would feel anxious beforehand but would try and put on a confident image when networking, hoping to gain research contacts.

The sensory considerations of networking

Katie created a painting of her experiences of masking which she attributed to a specific conference she had been to (see Figure 5.2). The painting shows a cracked mask in front of a multicoloured background. She wanted to create a Van Gogh-esque type background, to show how, when all the different aspects of the room feel too difficult to manage, they all blur together and become overwhelming. The cracked mask depicts that, as the environment becomes more unmanageable, the mask feels harder to wear.

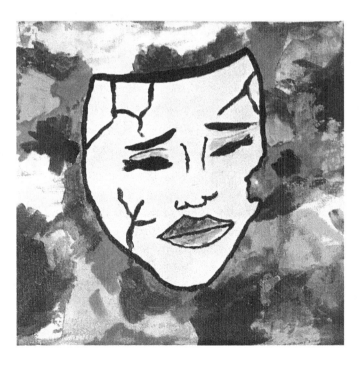

Figure 5.2: The Broken Mask, by Katie

Chapter 5: Navigating Conferences

She described her painting as reflecting her need to mask at networking events but is always at risk of not being able to keep it up and convince others. She is worried that other attendees might notice that she is autistic and think less of her. Her use of a standardised drama mask in the image might also suggest that she wants to conform to a perceived standard norm that is well recognised and accepted. However, she has given the mask a sad expression, suggesting that conforming to a norm makes her unhappy because it is not her true self. Katie also explains how she feels when masking during networking:

> *'First of all, you are masking that you are actually nervous about the room and the sound or just being in the wrong place or something like that, because you know that that's not what other people are thinking about. Then it's the mask where you have to pretend that ... you are interested in what other people are saying. Then it is ... that crack ... and it cracks your mask and makes it more difficult to wear... The background, I tried to do different colours to represent different aspects of the room, but that's why I, like, made it all smudged and blurry because that's how it felt, it just felt like it was just too much.'*
>
> (Katie)

Within her artwork and words, Katie highlights two main elements she feels she has to particularly focus on so that she can portray herself in a way she thinks others will view as acceptable: that she is competent in conversation and wants to engage with what others are saying and that the sensory environment does not impact her. Katie's primary concern is that she wants to appear competent in conversation. Cassy, meanwhile, will try to avoid networking so she does not have to mask what she is really feeling:

84

> *'When it comes to things like the coffee breaks or conference dinners, I am always trying to find reasons to leave it because I just find that overwhelming. I do not find it a good venue for forging links at all. And, you know, for example, you know when everybody gets together at a conference and they have cups of coffee and they talk and people sort of saying that is really when you do the real networking... And so, for example, I went to a conference recently, and whenever it was coffee time I would always have a conference call to go and meet, some emails to go and do, somebody to go and speak to.'*
>
> (Cassy)

Cassy accepts that she does not feel like she can forge links in that setting and therefore uses the time in a way that she feels is more productive for her. She does acknowledge, however, that coffee breaks are seen as an accepted way of making links and connecting with other academics, which is harder to do within formal presentations or via other methods such as online. By opting out of these more difficult social networking occasions, Cassy may have felt she had more energy to go to other parts of the conference and therefore had to prioritise what was most important for her. Yet it may be detrimental to her long-term prospects if she cannot ever engage in these situations considering the general perception of the importance of face-to-face networking.

Katie also discusses how she has to mask the impact of the sensory environment at conferences. She feels sound levels in a room can create a sensory overload, which leads her to worry that other people may notice her distress. The sensory elements of a conference were also of concern to Cassy, who also focuses on the noise levels of a room:

> *'It's the noise that it's just the noise... I can't hear. My head hurts, my ears hurt.'*
>
> (Cassy)

The main sense that both Cassy and Katie focus on is hearing and the angst it can bring before going into a conference, as well as how it makes them feel when they are there. This focus on the noise suggests that, for both Cassy and Katie, this is the most overwhelming and important issue at conferences. It is something they both have to hide in order to fit in and participate in the conference as a whole. Brown *et al* (2018) highlight that in-person conferences can be noisy environments and that it is imperative to have a quiet space that attendees can go to. They also advocate for a place inside the conference building where the conference is live-streamed so people can watch it and feel physically part of the conference while being in a quieter space.

While both Cassy and Katie focus on the sensory impact of noise, other sensory experiences can also impact the experience. I always worry about conferences that provide lunch. The provision of catering seems to be synonymous with many academic events and, to most people, this is an important part of the event. There also can be the expectation of networking while eating. I have found networking difficult due to struggling to initiate conversation, but this can be even harder when there is the added expectation of eating food that I am unlikely to enjoy due to a restricted diet. I have pressured myself at some conferences to eat what was provided in order to fit in, in an attempt to aid networking and to avoid any awkward questions surrounding food.

Now that conferences are more regularly online, or have online options, it is important to remember that they can still be sensorily overwhelming and that not everybody feels part of them (particularly as catering is not usually provided). I have been to online conferences where the background noise and lighting, while speakers were talking, were difficult for me to manage, which has made watching the conference difficult. It must be noted that there can be practical reasons that reduce an organiser's ability to increase inclusivity that are out of their control. Martin (2020a) considers that, although some conference organisers are keen to implement an environment that aims to reduce sensory stimulation, budget constraints and available resources such as catering and space can prevent this. These factors may be preventative to both in-person and online conferences. Overall, no one conference is likely to cater to every individual's needs and so it is important to think about the sensory impact a conference could have. In addition, organisers can assist potential attendees by asking them what may assist them and exploring what else conferences can do to increase inclusivity.

Networking summary

What is evident through both Cassy and Katie's descriptions of networking at conferences is the shared experience of masking in order to conform and the feeling that one is expected to be social and make connections over coffee breaks and unstructured time. The sensory environment of the conference adds an element of extra labour that they have to endure and navigate which other attendees may not experience. Considering that conferences can provide environments which may be difficult to navigate for autistic people, not attending would avoid these situations. However, not engaging in networking may lead to academic isolation, and therefore a reduction in collaboration and career enhancement opportunities. Farahar and Foster (2021) also argue that autistic people can miss out on opportunities by struggling to network. They therefore suggest that either non-autistic colleagues could positively reach out to autistic colleagues to include them in collaborations (thus removing the need to initiate conversation) or that more emphasis be placed on other forms of networking (such as via online platforms or in less sensorily overwhelming environments). The need to ensure networking is accessible to ensure equity of opportunities is therefore vital, particularly so autistic postgraduate students are not disadvantaged.

Presenting

Another important aspect of attending conferences is the presenting work. In my research, Katie enjoyed presenting her own research as she received good feedback from members of the audience which boosted her self-esteem and confidence.

Figure 5.3: The Conference Presentation, by Katie

Her depiction of this is shown in Figure 5.3 – an audience all smiling and looking engaged at what she was saying. Interestingly, she has placed a photo of herself presenting as a very small image in the corner in comparison to the large speech bubble containing her conference presentation. This may suggest she either places more emphasis on what she is saying or that she does not feel confident in herself as a presenter. Katie went on to talk about the feedback she received from the presentation:

> *'That conference, where I felt like I presented*
> *the best I ever have ... I had great feedback.*
> *I had some friends in the audience as well,*
> *who had not heard me speak before and they*
> *were really, you know, they said that I light up*
> *the minute I go on the stage and talk about*
> *something that I'm interested in. So, I wanted to*
> *kind of link that to your, you know, your special*
> *interest and how you can really harness that*
> *in a conference environment, whereas before*
> *I've really struggled with that.'*
>
> (Katie)

Katie implied she enjoyed presenting, which was cemented by feedback from her peers. Katie said she had great feedback and recalled that her friends said she 'lit up on' stage. Positive feedback clearly aided her self-esteem and feelings of self-worth in both her ability to present and her knowledge of the topic she was researching. This emphasises the benefits of collegiality and support from others, going against an established competitive element that often shrouds academia (Gaudet *et al*, 2022). Katie presented in person, and is it questionable whether she would have received as much feedback in an online format. When online presenters are just presenting to a screen rather than a room full of people, they may experience reduced anxiety, however this lack of engagement in online conferences may also be negative for a presenter because encouragement and feedback can be reduced. In relation to autistic students specifically, the required social networking to get to a level of collegiality may be difficult due to stereotypical difficulties with

communication and socialising, however, presenting at a conference may provide a talking point during networking. The benefits and drawbacks of which environment to present in (online or in person, where a choice is given) is something for careful consideration in relation to collegiality.

The overall experience

The combination of how Cassy, Katie and I have navigated different aspects of conferences is interesting to explore. We have all experienced a mixture of enjoyment and difficulty at conferences. Cassy did not mind speaking to large groups of people but found it difficult to network during unstructured times. Katie enjoyed presenting and receiving feedback, but did not like the sensory environment. I was grateful to network with others but did not enjoy the process. The need to fit in and act in a similar way to others is evident – something that many autistic people feel is important. Masking is a technique that may be employed in order to achieve this, and it may be something that autistic postgraduate students need to employ, but it can be dangerous (even if a person does not feel it is a choice, or a conscious act) or confusing. This is particularly the case as people can have negative experiences whether masking or not, thus making them feel that neither technique is useful, and potentially lowering their self-esteem (Miller *et al*, 2021). Although masking may enable an autistic person to fit into a situation and be perceived as conforming to a norm, this can lead to a reduced sense of self and confusion over self-identity (Miller *et al*, 2021). For example, Katie speaks about feeling confident talking about something she is particularly interested in and so not deliberately hiding her autism, but she tries to hide her autistic self when networking in order to fit a perceived norm, which could be potentially confusing to others and herself. This unsureness in how to come across at a conference and predicting the aspects that other academics may not want to see can be exhausting and energy consuming. The ultimate goal for conferences is that all participants should feel comfortable at events without needing to mask.

Concluding thoughts

In this chapter, I have highlighted how autistic postgraduate students may feel at academic conferences. Specifically, I have shared Cassy and Katie's experiences of attending conferences from my PhD research, alongside my own, focusing on networking and presenting. Both Cassy and Katie

emphasised how difficult it was to interact with other conference attendees in order to participate in networking. They cited various barriers, such as sensory overload and not knowing the expected social etiquette behind networking, and worried that, if they did not engage with this in a way that 'passed' as neurotypical, they would not be welcome. Presenting and obtaining good feedback was, however, a positive experience that Katie had while being at a conference.

Thus, suggesting that, while conferences are an important part of academia, they may include more challenging aspects alongside beneficial gains for autistic people. Covid-19 prompted working and conference cultures to change, and many academic events have become completely virtual or hybrid. It should be noted that while a hybrid approach may alleviate some exclusion for autistic people and may ensure people have the choice of how they engage, it does not instantly make a conference accessible. While accommodations such as a hybrid approach may help, with the aid of facilitators, the culture at conferences around networking and the importance put on it need to change to move towards full inclusivity for autistic researchers. There may not be a solution to this yet, however listening to any suggestions from autistic academics and striving to provide accessible environments as a standard, rather than only when accommodations are requested, may help in achieving full inclusivity.

References

Aiston, S-J., & Fo, C. K. (2021). The silence/ing of academic women. *Gender and Education*, **33**(2), 138-155. https://doi.org/10.1080/09540253.2020.1716955

Brown, N., Thompson, P., & Leigh, J. S. (2018). Making academia more accessible. *Journal of Perspectives in Applied Academic Practice*, **6**, 82–90. https://doi.org/10.14297/jpaap.v6i2.348

Byrne, J. (2022). Perceiving the social unknown: How the hidden curriculum affects the learning of autistic students in higher education. *Innovations in Education and Teaching International*, **59**(2), 142-149. https://doi.org/10.1080/14703297.2020.1850320

Cage, E., De Andres, M., & Mahoney, P. (2020). Understanding the factors that affect university completion for autistic people. *Research in Autism Spectrum Disorders*, **72**, 1015-19. https://doi.org/10.1016/j.rasd.2020.101519

Callus, A-M. (2017). Making disability conferences more actively inclusive. *Disability & Society*, **32**(10), 1661-1665. https://doi.org/10.1080/09687599.2017.1356059

De Picker, M. (2020). Rethinking inclusion and disability activism at academic conferences: strategies proposed by a PhD student with a physical disability. *Disability & Society*, **35**(1), 163-167. https://doi.org/10.1080/09687599.2019.1619234

Donlon, E. (2021). Lost and found: the academic conference in pandemic and post-pandemic times. *Irish Educational Studies*, **40**(2), 367-373. https://doi.org/10.1080/03323315.2021.1932554

Farahar, C., & Foster, A. (2021). #AutisticsInAcademia. In N. Brown (Ed.), Lived experiences of ableism in academia: Strategies for inclusion in higher education (pp. 197-216). Policy Press.

Gaudet, S., Marchand, I., Bujaki, M., & Bourgeault, I. L. (2022). Women and gender equity in academia through the conceptual lens of care. *Journal of Gender Studies*, **31**(1), 74-86. https://doi.org/10.1080/09589236.2021.1944848

Gordon, S., & Gledhill, K. (2018). What makes a 'good' conference from a service user perspective? *International Journal of Mental Health and Capacity Law*, **23**, 109-128. https://doi.org/10.19164/ijmhcl.v2017i24.686

Irish, J. (2020). Increasing participation: Using the principles of universal design to create accessible conferences. *Journal of Convention & Event Tourism*, **21**(4), 308-330. https://doi.org/10.1080/15470148.2020.1814469

Jones, S. C. (2023). Autistics working in academia: What are the barriers and facilitators? *Autism*, **27**(3), 822-831. https://doi.org/10.1177/13623613221118158

Leedham, A., Thompson, A. R., Smith, R., & Freeth, M. (2020). 'I was exhausted trying to figure it out': The experiences of females receiving an autism diagnosis in middle to late adulthood. *Autism*, **24**(1), 135-146. https://doi.org/10.1177/1362361319853442

Lindsay, S., & Fuentes, K. (2022). It Is Time to Address Ableism in Academia: A Systematic Review of the Experiences and Impact of Ableism among Faculty and Staff. *Disabilities*, **2**(2), 178–203. http://doi.org/10.3390/disabilities2020014

Martin, N. (2020a). Practical scholarship: Optimising beneficial research collaborations between autistic scholars, professional services staff, and 'typical academics' in UK universities. In H. Bertilsdotter Rosqvist, N. Chown, & A. Stenning (Eds.), *Neurodiversity studies: A new critical paradigm* (pp. 143–155). Routledge.

Martin, N. (2020b). Perspectives on UK university employment from autistic researchers and lecturers. *Disability & Society*. 1-21. https://doi.org/10.1080/09687599.2020.1802579

Mellifont, D. (2021a). Ableist ivory towers: a narrative review informing about the lived experiences of neurodivergent staff in contemporary higher education. *Disability & Society*, 1-22. https://doi.org/10.1080/09687599.2021.1965547

Mellifont, D. (2021b). A Qualitative Study Exploring Neurodiversity Conference Themes, Representations, and Evidence-Based Justifications for the Explicit Inclusion and Valuing of OCD. *The International Journal of Information, Diversity, & Inclusion*, **5**(2), 111–138. www.jstor.org/stable/48645276 (accessed July 2024)

Miller, D., Rees, J., & Pearson, A. (2021). "Masking Is Life": Experiences of Masking in Autistic and Nonautistic Adults. *Autism in Adulthood*, **3**(4), 330-338. http://doi.org/10.1089/aut.2020.0083

Oester, S., Cigliano, J., Hind-Ozan, E., & Parsons, E. (2017). Why Conferences Matter—An Illustration from the International Marine Conservation Congress. *Frontiers in Marine Science*, **4**(257). https://doi.org/10.3389/fmars.2017.00257

Oliver, C., & Morris, A. (2020). (dis-)Belonging bodies: negotiating outsider-ness at academic conferences. *Gender, Place & Culture*, **27**(6), 765-787. https://doi.org/10.1080/0966369X.2019.1609913

Pearson, A., & Rose, K. (2023). *Autistic Masking: Understanding Identity Management and the Role of Stigma*. Pavilion Publishing.

Sedgewick, F., Hull, L., & Ellis, H. (Eds.). (2021). *Autism and masking: How and why people do it, and the impact it can have*. Jessica Kingsley Publishers.

Waterfield, B., Beagan, B. L., & Mohamed, T. (2019). "You Always Remain Slightly an Outsider": Workplace Experiences of Academics from Working-Class or Impoverished Backgrounds. *Canadian Review of Sociology/Revue Canadienne de Sociologie*, **56**(3), 368–388. https://doi.org/10.1111/cars.12257.

Chapter 6:

The sensory environment of the university

Talking about sensory sensitivities has become somewhat inescapable when discussing autism. This may be because it is an area of autism that most people know, or think they know, most about. Investigating sensory sensitivities is also gaining popularity in research as they can have huge impacts on autistic people's lives, but research about this in relation to autistic postgraduate university student still remains fairly minimal. Not every autistic person is affected by sensory stimuli, such as noise, light or taste, but it is common for autistic people to either crave or dislike certain sensory experiences, which in turn can impact their happiness in different environments.

Difficulties with the university environment were the most frequently discussed aspect in my PhD study, however Creaven (2024) argues that little attention is given to the sensory environment and its impact on how neurodivergent students learn. In addition, Dwyer *et al* (2021; 2023) argue that neurotypical university staff have a poor understanding of the sensory issues autistic students may experience and therefore are unwilling to accommodate them. I therefore wanted to devote a chapter to the ways in which the university environment can impact autistic people. This is both to showcase lived experiences and to increase knowledge of this important issue. I touched on sensory aspects that can be present at conferences in

Chapter 5, but the environment at a person's 'home' at university is just as important given its vital role in supporting or impeding students' abilities to achieve.

In this chapter, I aim to demonstrate some ways in which the university can impact a person's sensory experiences. I explore some sensory experiences in various locations within universities, including the library, lecture theatres, postgraduate student accommodation, the shared office and the student's union, to spotlight some areas of the university that need to be considered in more detail to optimise autistic students' experiences.

The sensory experience in university spaces

Libraries

Libraries are key places of academic learning and progression for students and could be considered one of the most important places that a student interacts with at university. Libraries are moving away from being simple archives of information (with physical resources) to being learning-centred spaces (Lofty *et al*, 2022). Historically, the way resources are chosen and organised, and their physical environment, can be exclusionary to many people, including disabled people (Dahlkild, 2011). As technology continues to improve, and the a need grows for library buildings to be repurposed as spaces for learning (sometimes referred to as information commons) rather than spaces for information retrieval, it is important that they remain inclusive. Imrie and Kumar (1998) suggest that, for spaces to be inclusive, disability has to first be problematised as a socially constructed dynamic and chaotic concept, and second, there has to be a commitment to including many types of disability labels into a space (rather than focusing on a singular stereotype). In order for libraries to remain key places of learning as they change in purpose and physical state, disability needs to be considered.

The physical environment of libraries featured in the artefacts and interviews of many of the participants in my study, indicating their importance as spaces. They were clearly places that the participants considered essential to completing a university course, but the environment of such spaces tended to be mentioned negatively in regard to the sensory difficulties encountered. Kim documented her sensory experiences of the library in a poem.

Chapter 6: The sensory environment of the university

Concentrate, by Kim

Concentrate.
Noises all around,
Rustles, chewing, talking,
Distracted by the sound,
Perhaps I can calm down by walking.

Concentrate.
Colours everywhere,
Blue, yellow, green and red,
Even splattered in my hair,
I have so many words ahead.

Concentrate.
Don't work by the café,
Paninis, potatoes, cake,
It all smells like a buffet,
I can't bring myself to retake.

Concentrate.
Sipping on even plain water,
Leaves a distraction on my tongue,
I love my work like a daughter,
Yet all these tastes have clung.

Concentrate.
My work becomes a special interest,
Yet especially when a deadline presses,
Everything overwhelms me,
And my routines fall apart.

Kim's poem 'Concentrate' includes a stanza about every sense, and she depicts her frustration that other students can seemingly leave writing an assignment until just before a deadline. She feels unable to do this because, if the sensory environment in the library is not right for her, she is unable to work. Her poem suggests that other students are not impacted by the sensory things that annoy her in the library. This is further emphasised by Kim's use of rhyming couplets to provide a rhythm in the first five stanzas which are about senses. This rhythm

95

possibly represents how it appears that every other student can combine daily sensory experiences into their routine or that they do not notice them as they fit into the rhythm of everyday life. However, the last stanza does not follow the same rhyming structure. In this stanza, Kim talks about how her routine is disrupted by not being able to concentrate because of all the sensory distractions.

University learning involves much self-directed study, where the boundaries between learning and other activities, such as eating and socialising are poorly defined (Boys, 2011). This stands in contrast to school environments where learning and other activities are kept very separate. Boys' (2011) implication – that boundaries are blurred at university – resonates with Kim's poem, especially in her stanza about food and the sensory impact it has on her learning. Such blurred boundaries between learning and other activities may be conducive to learning for some students but not others. Cox (2022) and Lofty et al (2022) suggest that university libraries should incorporate a wide range of different spaces to accommodate as many study styles as possible.

Billy also highlights in her artefact (see Figure 6.1) how the library involves high sensory processing. She attributes this in part to why it took her seven years to feel comfortable going into a university library to check out books.

Figure 6.1: Untitled, by Billy

Billy's composition of her artefact demonstrates how she feels about the library. The books stacked up haphazardly may reflect Billy's description of how complicated she finds the system within the library to navigate. The description could be interpreted as showing anger rather than pride (at using the library for the first time). Words such as 'momentous occasion' seem to be used sarcastically to highlight how a task that is commonly seen as basic has taken so long to achieve due to the barriers she feels are put in place by the library systems. Billy also highlighted how libraries are loud and that it is difficult to find a quiet place, despite the fact that libraries are supposed to be quiet places. Poppy also found that the library was not quiet, which she thought strange given the stereotype that libraries are places for quiet study:

> *'So I can tell you about, like, some of the things that have been really weird this year, which is things, like, you will go to a library to have a quiet place to study but then the library wouldn't be quiet.'*

> (Poppy)

The assumption that physical libraries are quiet retreats for those who dislike noisy environments can be particularly challenging for autistic individuals, who may discover that these spaces are actually noisy and thus exclusionary. Ensuring that students are provided with detailed and accurate information about how a space may be used by other students, with particular regard to the senses, may help autistic students decide how and when to use them (in the interim, before spaces are made more inclusive).

Kim, Billy and Poppy highlight the sensory aspects of libraries[5]. Their sensory experiences somewhat align with the limited literature on autistic students' experiences of university libraries. Anderson (2018) suggests that, although libraries can be used by autistic students to escape other sensory environments, they are problematic spaces that are usually too noisy or too quiet to be comfortable. In addition, Lawrence (2013) and Pionke (2017) suggest that fluorescent lighting used in universities may also impact the sensory experiences of autistic students. Lawrence (2013)

5 It should be noted that participants only mentioned libraries as a physical spaces to be problematic, rather than online library collections or other resources.

also highlights how the trend at many universities towards emphasising group work has made libraries increase the number of collaborative and group workspaces, where students are expected to be noisy. She states that this could be overwhelming for autistic students.

The sensory difficulties of library environments experienced by the participants in my research appear to stem from both the physical environment (for example, Kim smelling the cafe) and how other people use the physical space. A common thread across the three experiences is the impact of noise. Changes in both the physical environment and the behaviour of others within it therefore need to be considered to ensure that library spaces are accessible to autistic students. Cox (2022, p9) states, 'to be welcoming the library space has to respond to all these differences and seek to accommodate them'. This may mean ensuring there are supported quiet places, access to a variety of types of spaces or specific times of the day when sensory overwhelm is considered more seriously.

Lecture theatres

Attending lectures is a common part of learning at university, particularly for postgraduate taught students (for example many master's courses). The places in which lectures take place may impact learning outcomes for autistic students. Kim found lecture theatres to be distracting, with lots of sensory input. She depicted the sensory distractions when she was in a lecture theatre and, again, particularly focused on noise (see Figure 6.2).

Figure 6.2: Sensory Stimuli in a Lecture, by Kim

Kim's image is drawn from the perspective of sitting at her laptop in a lecture theatre. The yellow is the academic work that she should be concentrating on (including her laptop and the presenting speaker) and all the other colours show distractions. She uses the blurry colours to show how her attention gets pulled between all the distractions. Kim describes the distractions as both coming from her own laptop (such as emails and social media notifications) and from within the lecture theatre (such as other people walking in late, whispering and sneezing). Overall, she described that she wanted her image to depict her sensory sensitivities, especially the auditory stimuli in a lecture theatre. This was to represent how difficult it is to concentrate when she is distracted, but also to show how other students seem to be able to focus despite distractions when she cannot. What is interesting is that she does not focus on the aspects of the physical environment, such as lighting, which is commonly brought up in discourse about autism. All of the sensory sensitives that Kim talks about are produced by other people, whether they are aware of it or not, and by technology.

Creating an environment of understanding that can enhance learning conditions could help to accommodate everybody within a lecture. The attitude of the lecturer may be vital to creating such an atmosphere. How Sheppard (2021) approaches lectures is very notable. She discusses how she is a disabled lecturer and so seeks to set up an environment of mutual support in her lectures. She is very clear that, although she is not able to change the physical design of a lecture theatre, accommodations can be made to ensure everybody's comfort. She explains that she does this by disclosing that she is disabled and stating what she needs to support herself when teaching. She then states she will help accommodate any student (for example, by having a system for reserving seating). This approach can normalise difference and disability, and emphasises that every student may have differing needs. Although Sheppard openly says that this is primarily to accommodate her own needs, it can also benefit her students. This understanding between Sheppard and her students may foster a culture which accepts that adaptations to improve the learning environment are possible and necessary. If an approach similar to Sheppard is adopted more generally by lecturers, then the difficulties and anxieties of lecture theatres can potentially be reduced for autistic students.

Disclosing a disability to create an environment that mutually benefits both staff and students requires a level of confidence and trust in the other people in the room. While Sheppard (2021) disclosing her own

disability (which is not being autistic) has benefitted her and others, an autistic woman disclosing may not receive the same reception. While I was studying as a postgraduate student, I did teach some seminars to undergraduate students. I started my sessions with each new group of students by talking about accessibility, how I hoped that the space would be as inclusive as possible, and that I was willing to change my teaching to meet their needs. I did not explicitly disclose my autistic identity (although this information is easy to find on my public-facing social media) as I was unsure how it would be received. I feel more confident now that I have completed my PhD, but at the time I was worried that students might not be happy being taught by somebody of my intersectionalities (being a PhD student and being autistic). This nervousness is now echoed in the research. Kaupins and Chenoweth (2024) explored the initial reactions of undergraduate students to two autistic academic – one male, one female – disclosing their autism. Participants did not change their impressions when an academic woman disclosed that they were autistic, but their impressions of the males rose when their autistic identity was revealed. In essence, men who disclose are viewed favourably, like being autistic and being in academia is an achievement, whereas women are perceived no differently and may be somewhat expected to be no different to their neurotypical women counterparts. Therefore, although disclosing my autism might not have negatively affected students' perception of my teaching, I did not experience any benefits or feel that the adjustments I wanted to make to the environment were accepted.

In summary, lecture theatres likely form an important part of a postgraduate student's studies, particularly if they are on a taught course. Current buildings may not be easy to change, for example due to a university's finances or willingness, but the behaviours of other students may be much easier to modify. This might include lecturers carving out time in preliminary lectures to explicitly promote collegiality and difference (not necessarily just about disability) or offering to discuss individual accommodations with students.

Accommodation

While it is most traditional for undergraduate students to live in university accommodation, postgraduate students may do so too, especially if they only attend a one year course. Some literature (for example Goddard & Cook, 2022; Jackson *et al*, 2018; Knott & Taylor, 2014) briefly explores the social experiences of autistic students living in student accommodation,

but rarely explores the impact that sensory aspects autistic students may experience. Dwyer *et al* (2023) are a notable exception, who recommend that there should be quiet spaces for autistic students to go to or accommodation blocks and surroundings that have rules around noise limits. In my PhD research, Sarah spoke about how she found her university living accommodation to be sensorily overwhelming, particularly in relation to noise. She lived in halls that were next to a cathedral. Sarah depicted this in a painting (Figure 6.3), which shows a black bell with a person as the clapper, in front of a multi-coloured background with times in 15-minute increments.

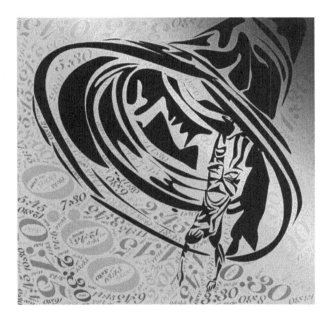

Figure 6.3: Untitled, by Sarah

Sarah explained how her life at university was controlled by the cathedral bells. They rang regularly, starting at 7:25 am and going on into the night, up to every quarter of an hour each day. She therefore 'lived and died by the bells' as they disrupted her sleep and she was never asleep after the first 7:25 am bell. Sarah represented herself as the clapper in the bell as she felt like she was being controlled by the bells, and could not stop them at any time – she was always part of the noise. The bells provided Sarah with structure, but she said it was unyielding.

She felt it defined her university experience as it was inescapable and made her unwell and exhausted quickly. Van Hees *et al* (2015) recommend that universities ensure autistic students have sufficient time to rest in order to reduce stress and anxiety from academic and social demands. However, Sarah was unable to find this rest due to the noise in her accommodation, which in turn affected her academic progress. The need for rest may be the same for all students, and thus noise might be a problem for everyone. She said that, because the bells had rung from the cathedral so often for hundreds of years, it was not something that could be changed, meaning that long-standing tradition and/or a university's ability to adapt its accommodation was put in front of students' comfort. In Sarah's situation, the university could have changed its accommodation by providing better wall insulation and taking other noise-reducing measures.

Although not regularly focused on in research, the sensory impact of halls may significantly impact other areas of an autistic student's university experience, particularly if they do not allow space to rest and recuperate. Dwyer *et al* (2021) focus on how sensory sensitivities might impact a student's accommodation experiences at university. They argue that autistic students are vulnerable to sensory overload and so need to have a quiet place to go to, so they can recover. They also highlight that, in catered accommodation, food sensitivities should be catered for in order to reduce students' anxieties and sensory overload. Dwyer *et al* (2021) advocate that new buildings in universities should have sensory refuges built into them to make access for neurodiverse students easier. Although they focus on typical American university accommodation (such as rooms shared by more than one person that are fully catered), which varies slightly from standard UK accommodation, they highlight the need to consider sensory difficulties in another aspect of the university experience. These three studies (Dwyer *et al*, 2021; Goddard & Cook, 2022; Van Hees *et al*, 2015) emphasise how difficult and overwhelming sensory disturbances can be, things that non-autistic people may be able to ignore. Dedicating some accommodation to have reduced noise levels could benefit other groups of students, for example students who do not want to or cannot drink alcohol may wish to live there, as events that include alcohol can become noisy and potentially unenjoyable for those who remain sober.

The shared office

When completing a postgraduate research course, it is likely that a student will be offered a place to study other than the university library, such as shared offices. Martin (2021) explored the experiences of 12 autistic academics with the aim of considering what universities could do better to support autistic academics. She included PhD researchers as part of this. Martin (2021) found that hot-desking in shared offices caused some of her participants difficulty as there were no boundaries for communicating with others, and could easily cause sensory overload due to the behaviour of other people. I found that working in an open-plan office during my PhD enabled me to be part of a community of academics, but also provoked anxiety when trying to work out the expected norms of office culture. Towards the beginning of my PhD, I built a Lego model of the office (see Figure 6.4). The computers were intended to be used as hot desks, but those who studied in there regularly tended to commandeer a desk as their own and personalise it.

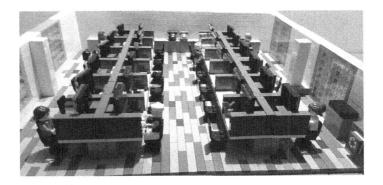

Figure 6.4: The Lego Office

The minifigures in my Lego office all represent a student who regularly studied there when the photograph was taken. I sat at the desk at the far back right-hand side. As people joined and left the space, I rearranged the minifigures and items on the desks. Building this Lego model started because I wanted some practice in building a model without pre-written instructions. It turned out to be something that I could look at and manipulate to consider how sensory and social events might happen. It also prompted me to further research the times of day when sensory issues most commonly arose, for example, the times of the weekly fire alarm was and Islamic prayer times in order to pre-empt when I needed to be respectfully quiet. While my model

did not influence anybody else's behaviour in the office, it helped me to plan ahead and process likely happenings in an environment over which I very little control. As the COVID lockdown came into effect, the office (both in real life and in my model, became empty). The model then became a reminder of an environment I had mostly enjoyed. But it was a depressing reminder of change – change that I had been through, and I had begun to feel comfortable in the space – to be able to predict how the space was used. Eventually, I broke up my model as I was unsure whether that environment, the atmosphere and those relationships could ever be recreated. By the end of the lockdown restrictions, some of the people I shared the space with had left and new people joined, and the desk I had appropriated had been taken over by somebody else. Adjusting to different people, different ways of working, and potentially a new office culture when I was that close to the end of my studies was too difficult, and so I never went back and never felt a sense of closure to my time working there.

I am sure that, throughout any academic career, I will have to navigate many open-plan offices, and I am unsure how I will find this. Maybe I will build the next space I work in out of Lego, or visualise it in another manner. It was something that allowed me to process some aspects of the office without actually physically needing to be there, so that I could focus on other elements, including studying, when I was in the room. This may be something that will help me in the future. Ensuring I am clear about expected office etiquette, including any boundaries surrounding communication and behaviour, would certainly assist me in understanding how to navigate such spaces in the future.

Social events such as student union nights

I have discussed how the sensory environment of some areas of university life can affect academic performance and the living conditions of postgraduate students. I now turn to how social events can be accessible or inaccessible with regard to sensory factors. Although academic and social events can intersect, some university events are purely focused on socialising, and these bring with them their own set of challenges.

Autistic students often feel that they do not want to attend social events because of the sensory overwhelm that can occur. As part of their research, Goddard and Cook (2022) explored the barriers which autistic students face when joining social events. They documented that the bright lights, overcrowding and noise levels that are common

in university spaces often make environments inaccessible. They suggest that, when universities renovate buildings, they should also consider 'invisible disabilities' such as autism, and until then, they should implement temporary strategies (for example reducing overcrowding as much as possible) to make environments less sensorily overwhelming. However, meeting the needs of everybody in one place can be particularly difficult and it therefore requires careful thought and planning. Goddard and Cook (2022) briefly note how autistic students who were able to attend social activities, such as social groups, with other autistic students had better experiences and an increased sense of belonging. It is important to ensure that social events at university are accessible in order to reduce sensory overwhelm so that autistic students have the same opportunities to engage in social activities and feel the sense of belonging that other, non-autistic students are likely to have.

A person's employment may provide opportunities to socialise and mix with other people, but can also provide sensory difficulties. Kim worked as a bartender during her studies and suggested how considering the sensory environment may be beneficial not only for autistic people but also for people working at these events:

> *'I'm also a bartender [in the student's union]. And … I'm very lucky that they understand that I'm not, they've not put me on the club night yet. I obviously would refuse it because we're a team and we help each other out, but they try and not put me on loud nights. But what about a silent disco, and things like that, and I think they had one at one of our balls, but making them more of a thing would probably quite help, because then you can adjust the sound and it's probably the easiest for the bartenders as well. I say it's someone can understand what someone's ordering and trying to make events more inclusive and quieter or just having different levels of sort of, like, or even sort of like, oh, at this point, we're not going to use lights and things like that.'*

> (Kim)

Kim highlights that she did not want to work on nights that were particularly noisy, but she considers how lower noise levels would in fact be a practical advantage for bartenders, too, helping them take orders and serve customers more easily. This is just one example of how accommodating the sensory needs of an autistic person could be beneficial to a much wider range of people, and serve as a catalyst for change, making events more accessible and creating a more positive societal image of autism. For Kim, aside from the sensory aspects, the job is unrelated to her degree and is likely to have helped her gain skills that could be transferrable to other areas of employment after university.

Socialising may happen in a variety of places, for example through university societies or through one's employment. One of my favourite jobs while studying was when I co-ordinated a university-run Saturday-morning playscheme for disabled children. None of my postgraduate studying was needed when I applied for this role, but I wanted to take the job I love working with disabled children. The job was therefore relevant to me in terms of my being disabled, but was not linked to my postgraduate studies. My role essentially meant I arranged activities, paired up a student volunteer with a child for the morning and oversaw a range of activities. I particularly enjoyed the job because the volunteers and other staff members present were interested in disability and therefore understood, or were willing to learn, about the effects of the sensory environment for some disabled individuals. It meant my job was a mixture of enjoying the type of work I was doing, but also of social value. To my knowledge, at the time there was no other comparable provision that was easily accessible. I believe this to still be the case.

Like most things, in lockdown, we stopped running these play sessions, and eventually it was decided the service would shut down permanently, which therefore included making redundancies. This was the first job I had not chosen to leave or which had reached the end of a contract. The change that I found most difficult to manage was not that my routine of attending every Saturday morning in term time had ceased, but rather that something I was passionate about, both the children having somewhere to play and for my own selfish social benefit, stopped for reasons beyond my control. The loss of the service meant the families had to find elsewhere for their children to play and the students involved had to find other places to get a similar experience. In addition, I missed the social aspect of being in a group of adults who were all keen to

champion disability and get involved in all of the trips and activities I organised. The change was also difficult because of the accepting environment of the playscheme, and how the other adults were willing to embrace discourse around sensory sensitives.

Universities often prioritise their academic functions over the social elements of university life. However, enhancing the sensory environment in spaces where social activities occur could significantly contribute to the overall university experience and help develop essential skills for future employment, particularly benefiting individuals on the autism spectrum.

Concluding thoughts

Overall, I have presented some areas at university which autistic postgraduate women, including myself, have struggled to navigate due to sensory difficulties, produced by both other people and the built environment. Sensory difficulties can prevent autistic students from participating in academic and social activities at university. It is therefore imperative that universities consider the impact of the environment on both learning and socialising, even if they are constricted by current the physical spaces and buildings available.

Universities may be able to reduce the sensory overload of many spaces and introduce social events like silent discos, and by helping to create a culture change in understanding how one's behaviour may affect others. In addition, providing accessible seating and workspaces as well as considering less-thought-of sensory impacts like taste and smell could help autistic students' learning. Most notably, considering the sensory environment may be influenced by the needs of an autistic person but can be beneficial for a much wider range of people, increasing accessibility on a broader scale.

References

Anderson, A. (2018). Autism and the Academic Library: A Study of Online Communication. *College & Research Libraries*, **79**(5), 645-658. https://doi.org/10.5860/crl.79.5.645

Boys, J. (2011). Where is the Theory? In A. Boddington & J. Boys (Eds.), *Re-shaping Learning: A Critical Reader* (pp.49–66). Sense.

Cox, A. (2022). Factors Shaping Future Use and Design of Academic Library Space. *New Review of Academic Librarianship*, 1-18. https://doi.org/10.1080/13614533.2022.2039244

Creaven, A. M. (2024). Considering the sensory and social needs of disabled students in higher education: A call to return to the roots of universal design. *Policy Futures in Education*, 1-8. https://doi.org/10.1177/14782103241240808

Dahlkild, N. (2011). The Emergence and Challenge of the Modern Library Building: Ideal Types, Model Libraries, and Guidelines, from the Enlightenment to the Experience Economy. *Library Trends*, **60**(1), 11-42. https://doi.org/10.1353/lib.2011.0027

Dwyer, P., Acevedo, S. M., Brown, H. M., Grapel, J., Jones, S. C., Nachman, B. R., Raymaker, D. M., & Williams, Z. J. (2021). An expert roundtable discussion on experiences of autistic autism researchers. *Autism in Adulthood*, **3**(3), 209–220. https://doi.org/10.1089/aut.2021.29019.rtb

Dwyer, P., Mineo, E., Mifsud, K., Lindholm, C., Gurba, A., & Waisman, T. C. (2023). Building Neurodiversity-Inclusive Postsecondary Campuses: Recommendations for Leaders in Higher Education. *Autism in Adulthood*, **5**(1), 1–14. https://doi.org/10.1089/aut.2021.0042

Goddard, H., Cook, A. (2022). "I Spent Most of Freshers in my Room"—A Qualitative Study of the Social Experiences of University Students on the Autistic Spectrum. *Journal of Autism and Developmental Disorders*, **52**, 2701–2716. https://doi.org/10.1007/s10803-021-05125-2

Imrie, R., & Kumar, M. (1998). Focusing on Disability and Access in the Built Environment. *Disability & Society*, **13**(3), 357-374. https://doi.org/10.1080/09687599826687

Jackson, S. L., Hart, L., Brown, J. T., & Volkmar, F. R. (2018). Brief report: Self reported academic, social, and mental health experiences of post-secondary students with autism spectrum disorder. *Journal of Autism and Developmental Disorders*, **48**(3), 643–650. doi:10.1007/s10803-017-3315-x

Kaupins, G., & Chenoweth, T. (2024). Impact of female and male university instructors revealing their high-functioning autism to their students. *Current Psychology*, **43**(1), 214-222. https://doi.org/10.1007/s12144-023-04268-y

Knott, F., & Taylor, A. (2014). Life at university with Asperger syndrome: a comparison of student and staff perspectives. *International Journal of Inclusive Education*, **18**(4), 411-426. https://doi.org/10.1080/13603116.2013.781236

Lawrence, E. (2013). Loud hands in the library: Neurodiversity in LIS theory & practice. *Progressive Librarian*, **41**, 98-109. www.progressivelibrariansguild.org/PL/PL41.pdf#page=102 (accessed July 2024)

Lofty, M. W., Kamel, S., Hassan, D. K., & Ezzeldin, M. (2022). Academic libraries as informal learning spaces in architectural educational environment. *Ain Shams Engineering Journal*, **13**(6), 101781. https://doi.org/10.1016/j.asej.2022.101781

Martin, N. (2021). Perspectives on UK university employment from autistic researchers and lecturers. *Disability & Society*, **36**(9), 1510–1531. https://doi.org/10.1080/09687599.2020.1802579

Pionke, J. J. (2017). Toward holistic accessibility: Narratives from functionally diverse patrons. *Reference & User Services Quarterly*, **57**, 48–56. www.jstor.org/stable/90014867 (accessed July 2024)

Sheppard, E. (2021). "I'm not saying this to be petty": reflections on making disability visible while teaching". In N. Brown (Ed.), *Lived Experiences Of Ableism In Academia: Strategies for Inclusion in Higher Education*. (pp. 185-196). Policy.

Van Hees, V., Moyson, T., & Roeyers, H. (2015). Higher Education Experiences of Students with Autism Spectrum Disorder: Challenges, Benefits and Support Needs. *Journal of Autism and Developmental Disorders*, **45**, 1673–1688. https://doi.org/10.1007/s10803-014-2324-2

Chapter 7:
Learning differently

Throughout university study, it is widely accepted that there will be times when a student may struggle with their work, need support, or doubt their academic capabilities. 'Imposter syndrome' refers to having intense feelings of being an intellectual fraud (Clane & Imes, 1978). Somebody with imposter syndrome may look for the negatives associated with their academic achievement, rather than celebrate their successes due to a fear of failure or a drive for perfectionism. Wilkinson (2020) argues that, while imposter syndrome is well documented in research, she notes that it can be hard to discuss in practice due to university culture. In addition, very little research explores autistic people's experiences of imposter syndrome. Neurodivergent students, who learn in ways that differ from perceived norms and stereotypical student behaviours, are likely to feel pressured by their inability to conform to traditional academic expectations (Spaeth & Pearson, 2023). It is crucial, then, especially for autistic postgraduates, that we normalise discussions about imposter syndrome, as their experiences, which often differ from those of neurotypical academics, seem to be less documented in research and deserve greater attention.

Many factors could contribute to autistic postgraduate students feeling imposter syndrome, in different ways to neurotypical students. Syharat *et al* (2023) say that neurodivergent students may feel more pressure to belong in academia than neurotypical students, due to their need to compensate for the difficulties they may have in completing academic work. Meadhbh Murray *et al* (2022) highlight that, although all students may expend time

and energy to counteract the feeling of imposter syndrome, marginalised students can experience these feelings more regularly and intensely, often fuelled in part by a non-inclusive university atmosphere.

In this chapter, I explore how elements of the university experience, such as receiving feedback and feeling that learning is occurring in different ways to neurotypical people, can hinder an autistic person's ability to study and affect the outputs they produce. Throughout this chapter, perfectionism and imposter syndrome are evident and I question whether these are more likely to be present for an autistic woman trying to portray 'competence', as defined by the mythical societal norm.

The expectation of negativity from learning differently

Autism is widely portrayed as a series of deficits, and as deviations from a mythical norm. It is therefore unsurprising that autistic people may internalise this negativity around completing tasks in ways that differ from neurotypical people. This could lead to imposter syndrome for autistic people in academia. The neurodiversity movement is attempting to challenge this deficit narrative by positioning neurodivergency (including autism) as a series of differences rather than deficits, while still acknowledging that support to assist with those differences may be needed (Ne'eman, 2010). A person's strengths and weaknesses are also often viewed in a very binary manner, which does not take account of the changeable nature of people's abilities, or that different environmental factors may affect a person's ability to perform (Russell *et al*, 2019). Something that is a strength on one day may therefore be a weakness on another, or a characteristic may be both a strength and a weakness at the same time. Society's prevailing idea of autism as a predominately negative thing is likely to contribute to how it is viewed in academia. While understanding autism purely in terms of strengths is likely to be equally dangerous, acknowledging that autism may not just include weaknesses or deficits may reduce stigma, both from others and from internalised stigma within themselves. Katie created an artefact showing the internalised negativity she feels about potential weaknesses. She described how she felt when she received feedback on her PhD thesis writing from her supervisor. Her words highlight how she was looking for negative feedback from her supervisor and how despondent she felt:

Chapter 7: Learning differently

The complicated map of feedback

I finally slump into my chair, the journey has exhausted me. There were so many things in the way, the smells, the sounds, the sights. I rub my eyes and open my laptop, waiting for it to connect to eduroam[6] and come to life. Once it does, I hear that familiar email sound and my heart starts to race, I get a sour taste in my mouth and suddenly the computer screen is so bright I have to squint. My heart is really beating now, a strong and familiar rhythm and it sounds so loud. I swallow, almost gasping for breath, and open the attachment.

My supervisor has sent me feedback on a chapter.

I quickly scan the comments on the right-hand side, rapidly looking for any words like 'stupid', 'no' or 'you should quit'. Instead, the comments are broad, ambiguous and use words I don't recognise. I panic, close the document and decide to look at it later. Classic fight or flight, except my default is flight.

I can't help myself but open the attachment again to take a 'proper' look at the feedback. Here are examples:

"I suggest we park this for the moment"

"this is superfluous"

"be clearer"

"define what you mean"

"needs introducing earlier, how about upfront?"

6 The university's intranet.

113

Chapter 7: Learning differently

> *I feel dizzy now, the words are swirling around
> in my mind. It's like navigating your way
> through a forest with a map you've never seen
> before and the code is symbols and words in
> another language. But you have to find your
> way to the end, so you aimlessly look at the map
> trying to make sense of it all. It takes hours and
> all you do is go around in circles.*

- *where am I parking what and for how long
 is a moment?*
- *What does superfluous mean and what do I do
 when something is?*
- *Be clearer where?*
- *Define which bit? Doesn't everyone know what
 this means?*
- *Upfront where? In the beginning, halfway through?*

> *I ended up crying. It was my only option. I had
> no idea what to do next and I couldn't ask my
> supervisor what she meant because that's rude
> and she would think I was questioning her. So, I
> spend hours walking around the map in circles,
> Googling what words mean and interpreting
> them in every way possible. I get more and more
> tired until I realise the moon is shining and I
> should be at home. I head home with my head
> hanging low and, with a big sigh, I think to
> myself "I'll try again tomorrow".*

Katie's expectation that she will receive negative comments about her
work highlights the imposter syndrome she has about her writing and the
lack of confidence she has in her ability. She experienced both a physical
reaction – feeling dizzy and panicking – as well as a mental reaction,
feeling not good enough. She said she added the word 'map' to the title of
this artefact as she felt the feedback she was receiving from her supervisor

was like a map, from which she had to figure out the right path, which caused her panic. Katie said that this type of feedback and the feelings she felt receiving it continued for a year:

> *'I had about a year of, you know, feeling really rubbish and being really down, feeling worthless, basically, because I didn't, I couldn't, understand the feedback I was getting so I was kind of writing in a way that made sense to me and I couldn't see it through the eyes of the other person. So, I'd either explain things in lots of detail that I didn't get to, or because I knew difficult concepts I'm just throwing them in without explaining what they are.'*
>
> (Katie).

Eventually, Katie and her supervisor discussed how feedback was making her feel and her supervisor suggested that they meet twice about each piece of work Katie submitted, although this took a year of feeling worthless to get to. The first session was to explore the feedback and then a second meeting would give Katie the opportunity to come back with further questions and ask for a 'translation' (as she termed it) to reduce ambiguity. This allowed Katie time to process her thoughts and frame questions in a way that she did not feel was silly, or that they were not up to the standard that she thought she should be achieving as a PhD student. Meeting a student twice for each feedback given could be beneficial to a student's self-esteem as feedback can be processed over a longer period of time and reflected on, enabling the student to act upon it in the best way possible.

Autistic students may work in different ways, some more like expected conventional norms and others possibly not, however it is more than likely that the overall goal will be the same such as the completion of an assignment. Billy felt that she was not learning in the same way as others were, which made her feel guilty.

'Autistic brains work differently and not conforming to the "normal" ways of learning comes with guilt and the feeling like you're not "learning right".'

(Billy)

Billy implies that it is not just the same goal that should be reached (which for her was completing her PhD) but that it should be achieved in the same way. The fact that Billy thought she was not learning in the same way as others exasperated feelings of guilt that she was in academia but was not 'normal'. I wrote the majority of my PhD sitting cross-legged on the sofa, with my laptop balanced on top of my knees usually in the late evening, while listening to Classic FM. This late-night working style may be more traditionally associated with an undergraduate student who is racing to meet an assignment deadline. A lot of my writing was completed close to deadlines, but this was not the primary reason for often writing late into the evening. It felt more freeing as I was not completing writing in the expected daylight hours, and because I was not conforming to that norm, I did not feel as worried about writing perfectly. If I was going against one norm, then I did not feel I needed to conform to others. This way of working was not always possible due to other commitments, such as teaching and attending conferences, but was mostly feasible.

Both Billy's, Katie's and my own experiences suggest a lack of internal acceptance of difference which may be because of not feeling able to reach an expected ingrained societal norm that we feel we cannot reach due to being autistic. The lack of societal discourse about the strengths associated with autism is likely to also contribute. In a sense, being given a poor grade is acceptable as that can happen to anybody, but feeling unable to understand feedback or learn in a similar way to others is not because that is not traditional.

Language mismatch

Not feeling good enough to study at the postgraduate level, which can of course contribute to imposter syndrome, could also be affected by the types of language that others use when giving instructions. Katie was asked to 'park' something by her supervisor, meaning to think about it at

another time and to first focus on more important tasks. She explains how that phrase was ambiguous even though she knew what it was relating to (her work, rather than a car):

> *'What does let's park it for a while mean? Well, for how long, how long do I wait, because I will sit and wait for a certain amount of weeks and then, you know, very, very strict on the rules.'*
>
> (Katie)

Similar to Katie, I encountered misunderstandings during my studies. As I began writing up my PhD thesis, one of my supervisors said I should 'sit' with my thesis. I felt slightly confused by this suggestion, but did not want to ask questions and dutifully followed her advice. I placed my laptop with my writing on and we watched television together. In hindsight, I now understand that my supervisor wanted me to take a break from writing to reflect upon what I had written and how I could expand it. Although I can laugh about it now, at the time I felt inadequate and not clever enough to be studying at PhD level, because I did not understand the advice I was given.

Misunderstandings between autistic and non-autistic people have commonly been termed in the literature as the Double Empathy Problem (DEP) (Milton, 2012), and it is widely accepted that, due to thinking differently, understanding between people of different neurotypes may occur. The emphasis of 'the problem' in such miscommunications has traditionally sat with the autistic person, but the DEP seeks to highlight that it is not solely the autistic person who should carry the blame, and that communication differences are due to lived experience and neurotype differences between both communication partners (Milton *et al*, 2022). It is therefore easy to just dismiss communication differences as something that happens and is therefore unchangeable. Finke and Dunn (2023) propose that understanding how communication can differ and be understood can affect an autistic person's sense of belonging. This is due to misunderstandings in communication leading to broken and halting conversations, and therefore to isolation, which is much more likely to happen to the autistic person in the scenario. Finke and Dunn (2023) suggest that any communication mismatch can be reduced by neurotypical people changing their perspective about how an autistic person should

communicate, accepting responsibility for how they communicate themselves and being more empathetic towards anybody who finds conversing difficult. This may be particularly impactful in situations such as Katie's, where misunderstanding and misinterpreting happened between her and her supervisors, who are in many respects the most important people in the journey of a PhD student.

Perspectives about how others communicate and being aware of how understanding may differ is important in academia, but it is important not to assume that academic ability and understanding of language are comparable or synonymous. This is particularly true for autistic students. University staff may assume that students for whom English is not their first language may require clear instructions and straightforward communication, but this assumption for clarity should be extended to all students to ensure that they (especially autistic students) are not disadvantaged by misunderstandings. Autistic academics should be given an opportunity to explain their communication preferences, and afforded the time and space to mitigate any issues.

How to be autistic in academia?

Several times I have questioned whether I am 'autistic enough' to claim the label of autism, particularly as I was academically able enough to write a PhD. Jones (2023) suggests that there is a societal assumption that autistic academics are rare and 'less autistic'. Furthermore, negative narratives about autism emphasise deficits that are not conducive to academic study, such as a stereotypical lack of creativity (Craig & Baron-Cohen, 1999) or not wanting to socialise (Chevallier *et al*, 2012; Bertilsdotter Rosqvist *et al*, 2023). Considering all these negative stereotypes that people hold about autism and autistic academics, I have often worried about how I might be perceived, and whether I will be thought of as a fraud. This is not to say that I do not have similar worries in other areas of my life, but the perception of a person's ability is so often based on their academic success in areas such as writing and mathematics that I feel it most keenly in relation to my academic career. This internalised imposter syndrome surrounding my identity therefore seeps into all aspects of my academic life. In medicalised thinking, I would be deemed to have a 'spikey profile' of autism, meaning that in some areas I excel, but in others I fall short compared to the average of the population.

Throughout writing this book, where I have included some of my own experiences alongside those of the participants in my PhD study, I have regularly questioned whether my experiences will be relevant to others, whether my autistic voice accurately depicts some of the challenges that academia presents, and if my experiences are actually very different after all to those of a neurotypical academic woman. In particular, I question whether I am 'different enough' from others – I want to fit in, but when writing on a topic, the emphasis and goal is usually to stand out from the crowd and to be noticed. All of these questions and thoughts regularly go through my head and sometimes become debilitating.

This worry that I am an imposter in the autistic community may never disappear, despite having paperwork to say otherwise. Jones (2023) goes as far as to suggest that academia is the ideal place for an autistic person, because it allows them to focus on topics of interest and therefore plays to the strengths of being autistic. Despite this, Bertilsdotter Rosqvist *et al* (2023) highlight that there are many neurodivergent academics in fields such as neurodiversity or autism research that are on precarious and temporary contracts, compared to the numbers of neurotypical researchers in those fields who are securely employed. There may therefore be a disconnect between the autistic skill set and the opinions of academia towards autistic people, which can contribute to internalised worry about being 'the right kind of autistic' to be in academia.

Autistic academics do of course exist and I have spoken about the autistic research community in Chapter 4. I also spoke in Chapter 2 about the stigma of being an autistic woman. This growing population and the camaraderie within it may help to relieve my imposter syndrome, particularly when there is so much stigma and stereotyping in society that make being an autistic academic a challenge. The most effective way I have found to counteract these feelings of being an imposter is by speaking to my friend Becky, who has also recently completed a PhD in the field of autism. She is also autistic. We met at the beginning of our postgraduate study journey at a wheelchair basketball tryout. I think both of us went along because it seemed to be a sport that looked most accessible and not one that many students would have played at school. We bonded over the fact we were both clearly not naturals at the sport and, through talking, we found we were both autistic and wanted to go into research. Since then, we have both gone on to study different areas within the field of disability at different universities.

When I first met Becky, I had not been diagnosed as autistic for very long and had not met any other autistic women. We have become good friends and I can ask her about any academic situation and what 'the right way' to approach something might be. We regularly conclude there is usually no right way, but being able to bounce ideas off of somebody who regularly experiences similar difficulties has allowed me to not always think that I am an imposter, but that others may feel and do similar things in academia. Alongside her formal academic work, Becky creatively documents autism research and key areas of thinking under her persona of *NeuroDivers*. I strongly believe that the comradery found in belonging to a community can in general be beneficial to achievement and success, and being able to listen to personal stories and 'real life' examples has really helped me. This is not to say that our relationship is not two-way or that we can fix each other's imposter syndrome on any given day. We virtually pass over a 'flag' with a saying of 'flying the flag for autism' to each other on some days. This simply means that if one of us feels unable to succeed on that day, it becomes the responsibility of the other to do something good. We may have become friends whether the mutual connection of autism and autism research was there or not, but our shared experiences of postgraduate study, in combination with being autistic women, have certainly helped me to feel like there are other people like me in academia, and that I should be part of it.

Overall, there is perhaps no 'right way' to be an autistic PhD researcher, but there is a fine line between fitting in enough to be accepted and standing out enough to be academically noticed.

Changing academic expectations

Various non-traditional learning methods have been proposed for academic settings. Things are slowly evolving in order to reduce the binary divides between intersectionalities in academia. The timeframe within which this is occurring, however, may not be ideal for academics who feel marginalised and excluded from current cultural norms and practices. Encouraging neurodivergent flourishing and neuro-mixed academia are possible ways in which inclusion could be reached for neurodivergent people.

Encouraging neurodivergent flourishing in academia is proposed by Spaeth and Pearson (2023) based on the principles of Universal Design

for Learning (UDL). They cite that UDL reduces the need for anybody to disclose access needs or diagnoses by creating a more flexible academia. Martin (2021) argues that this thinking can ensure that everyone's talents are appreciated, and neurotypicality is not treated as a gold standard to strive for. Spaeth and Pearson (2023) highlight practical ways to create flexibility for ND students, such as by valuing differences, not focusing on engagement indicators and allowing flexible working to achieve a defined goal. Ultimately, academics need to attempt to reduce the stereotypes they hold about how others, both students and other staff, may behave and learn in academia, and accept people's differences as potentially positive opportunities for collaboration and further learning. For autistic women, who are also defined by masculine stereotypes of autism, an extra layer of discrimination may be present (Harmens *et al*, 2022). Flexibility and acceptance of difference, to reduce academic and societal stereotypes, could therefore ensure the better inclusion of autistic women in academia.

Another such suggestion is the notion of a neuro-mixed academia. Bertilsdotter Rosqvist *et al* (2023) promote that academia could become an ideal space for cross-neurotype collaboration and community. This would mean that all academics are valued regardless of whether they were neurotypical or not, and that neurodivergency is seen as part of the intersectionalities of a person, rather than needing to be a prominent part of a researcher's identity. Bertilsdotter Rosqvist *et al* (2023, p1242) highlight that 'humans are messy, complex, chaotic systems, and to even begin to understand them we need to cross disciplinary boundaries, and neurological trenches to create better knowledge that serves us all'. By this, he meant that neurodivergence can be thought of as the most prominent part of a person's identity, whereas all intersectionalities should be viewed and treated as equally important, or indeed unimportant. In order for a neuro-mixed academic landscape to form, a culture shift towards destigmatising the opinions of academia towards minority cultures, including neurodivergent individuals, is needed.

These different ways of learning could be reimagined and written by neurodivergent scholars to be more inclusive and to highlight how they do not feel comfortable in academia. If academia was a perfect environment for neurodivergent people, then these imaginations and advocacy for

cultural change would not be necessary.

Overall, feeling like an imposter may be something that people are expected to experience during the academic journey, but it may affect autistic students' abilities to learn more often or more strongly than their neurotypical counterparts. This may be the case because autistic students and academics are likely to feel excluded, or that they are on the periphery of inclusion. The added layer of feeling academically fraudulent may be combined with trying to fit into a neurotypical world and way of studying. Providing time between giving students feedback on written work and meeting with them – once or more – may help to alleviate these feelings of imposter syndrome.

Neurodivergent academics are starting to challenge current thinking in academia and advocating for ways in which culture changes could occur to increase inclusivity, such as creating a neuro-mixed academia and increasing flexibility around ways of working. This advocacy, however, has to come from predominately neurodivergent academics, suggesting that a willingness from neurotypical academics to embrace the minority neurotype still exists. Cultural change at university towards one which is inclusive of neurodiversity and which values a variety of voices could not only provide a more welcoming experience, but could also ensure more collaborative research between neurotypes.

References

Bertilsdotter Rosqvist, H., Botha, M., Hens, K., O'Donoghue, S., Pearson, A., & Stenning, A. (2023). Cutting our own keys: New possibilities of neurodivergent storying in research. *Autism*, 27(5), 1235-1244. https://doi.org/10.1177/13623613221132107

Chevallier, C., Kohls, G., Troiani, V., Brodkin, E. S., & Schultz, R. T. (2012). The social motivation theory of autism. *Trends in Cognitive Sciences*, **16**(4), 231–239. https://doi.org/10.1016/j.tics.2012.02.007

Clance, P. R., & Imes, S. A. (1978). The imposter phenomenon in high achieving women: Dynamics and therapeutic intervention. *Psychotherapy: Theory, Research & Practice*, **15**(3), 241–247. https://doi.org/10.1037/h0086006

Craig, J., & Baron-Cohen, S. (1999). Creativity and imagination in autism and Asperger syndrome. *Journal of Autism and Developmental Disorders*, **29**, 319-326. https://doi.org/10.1023/A:1022163403479

Finke, E. H., & Dunn, D. H. (2023). Neurodiversity and double empathy: can empathy disconnects be mitigated to support autistic belonging? *Disability & Society*, 1-24. https://doi.org/10.1080/09687599.2023.2295802

Harmens, M., Sedgewick, F., & Hobson, H. (2022). The Quest for Acceptance: A Blog-Based Study of Autistic Women's Experiences and Well-Being During Autism Identification and Diagnosis. *Autism in adulthood*, **4**(1), 42–51. https://doi.org/10.1089/aut.2021.0016

Jones, S. C. (2023). Autistics working in academia: What are the barriers and facilitators? *Autism*, **27**(3), 822-831. https://doi.org/10.1177/13623613221118158

Martin, N. (2021). Perspectives on UK university employment from autistic researchers and lecturers. *Disability & Society*, **36**(9), 1510–1531. https://doi.org/10.1080/09687599.2020.1802579

Meadhbh Murray, Ó., Tiffany Chiu, Y., Wong, B., & Horsburgh, J. (2022). Deindividualising imposter syndrome: imposter work among marginalised STEMM undergraduates in the UK. *Sociology*, **57**(4), 749-766. https://doi.org/10.1177/00380385221117380

Milton D. (2012). On the ontological status of autism: The 'double empathy problem'. *Disability and Society*, **27**(3), 883–887. https://doi.org/10.1080/09687599.2012.710008

Milton, D., Gurbuz, E., & López, B. (2022). The 'double empathy problem': Ten years on. *Autism*, **26**(8), 1901-1903. https://doi.org/10.1177/13623613221129123

Ne'eman, A. (2010). The future (and the past) of Autism advocacy, or why the ASA's magazine, The Advocate, wouldn't publish this piece. *Disability Studies Quarterly*, **30**(1). http://dsq-sds.org/article/view/1059

Russell, G., Kapp, S. K., Elliott, D., Elphick, C., Gwernan-Jones, R., & Owens, C. (2019). Mapping the autistic advantage from the accounts of adults diagnosed with autism: A qualitative study. *Autism in Adulthood*, **1**(2), 124-133. https://doi.org/10.1089/aut.2018.0035

Spaeth, E., & Pearson, A. (2023). A reflective analysis on how to promote a positive learning experience for neurodivergent students. *Journal of Perspectives in Applied Academic Practice*, **11**(2). https://doi.org/10.56433/jpaap.v11i2.517

Syharat, C. M., Hain, A., Zaghi, A. E., & Gabriel, R. (2023). Experiences of neurodivergent students in graduate STEM programs. *Frontiers in Psychology*, **14**, 1149068. https://doi.org/10.3389/fpsyg.2023.1149068

Wilkinson, C. (2020). Imposter syndrome and the accidental academic: An autoethnographic account. *International Journal for Academic Development*, **25**(4), 363–374. https://doi.org/10.1080/1360144X.2020.1762087

Chapter 8:
Autistic advocacy

With disability, or indeed with any deviation from a societal norm, advocacy is frequently necessary. This may involve self-advocating for inclusion in society, or it may involve advocating on the behalf of others. For autistic people, advocacy and ways in which it takes place may be different from other disabled individuals due to it not necessarily being apparent to other people (Sapir & Banai, 2023). Advocacy, both for and about autistic women, is a particularly important issue, as women are not regularly featured in autism discourse (Hoyt & Falconi, 2015). This can mean additional labour for autistic women, to ensure that their voices are listened to and their words acted upon. This is especially because feminism champions the equality of women, but does not always include disabled women (Garland-Thomson, 2002). In academia, where people are held to a certain academic standard, requiring adjustments or changes can be viewed unfavourably or met with resistance. If advocating is successful, however, it can lead to change, but the debate remains as to whether autistic women should have to self-advocate or whether others should do so on their behalf. There is a danger that advocators may become 'self-narrating zoo exhibits', regularly having to repeat their stories and experiences to improve current practice and inclusion (Sinclair, 2005). If other people are more knowledgeable and willing to be inclusive, self-advocacy for autistic women may be reduced. I present how self-advocating and advocating for the autistic community, in general, can impact autistic academics, including additional labour and the effects of other people's responses to it.

Self-advocacy

Unfortunately, it is inevitable that autistic women will have to advocate for themselves at different points throughout their academic journey, due to the small (but growing) visibility of autistic women in academia. The need for autistic students to advocate for themselves is also recognised in the literature, for example, Bailey *et al* (2020) argue that autistic students need to be taught self-advocacy and assertive communication skills to be able to self-advocate and challenge discriminatory behaviour they encounter. This need to be able to self-advocate may be based on the idea that, to succeed in postgraduate study, a student may have to undertake activities that do not match up to stereotypical autistic strengths, such as attending interviews and vivas that require eye contact and conventional communication styles (Chown *et al*, 2016). Therefore, in order to change or adapt these processes, advocacy is required, which tends to fall on the individual requiring the adjustment.

My academic 'claim to fame' – or greatest failure, depending on how one looks at it – came while studying a psychology master's course. One of the optional modules was about autism, which included theories and some exploration into how an autistic child might develop. It was mainly based on the science of autism, rather than the politics and the lived experiences of autistic people, but it looked interesting and it was a module I thought I would be able to succeed in. I believed this because I had, of course, developed as an autistic child, and was interested in literature about autism. The module was assessed through a closed-book exam and involved writing two essays. Most students at the time tackled these types of exams in the department by remembering several pieces of research they could cite to enhance their writing before the exam and writing them all down as a list as soon as the exam started before forming their answers. I did not have much experience of completing examinations of this nature before this module. I was not as good at remembering lists of researchers and was not therefore able to write down that many names as the exam started, which impacted my writing due to anxiety about referencing. Perhaps I was a bit overly confident in my knowledge of autism, or that it would be relevant to the desired learning of the module, but I was sure I would pass anyway. I failed the exam, and therefore the module. It felt silly that as an autistic person – a so-called 'expert by experience' – I would fail a module aimed at giving

a broad overview of autism, in an area that I wanted to research. I had scored badly on all the exams I had taken, regardless of the topic, but this was the only one I had actually failed.

This experience prompted me to see if I could get some extra support for exams, which I had not previously considered. I was met with general excuses about ensuring all students were assessed in the same way, but after some discussion and negotiation, I was allowed to take in a list of researchers' names and some notes about each piece of research that I wanted to talk about. Following on from the style of my exams being changed, my scores for the second semester vastly improved. Since the lockdown, many exams remain online meaning that they are inevitably open-book exams, so perhaps the self-advocacy I had to engage in will now be unnecessary for some university students. However, ensuring that exams are not predominantly memory tests is still important so as to not to disadvantage students for whom remembering facts or names is difficult – a skill that, in most jobs, would be unnecessary as long as a person knew where to find such information.

With regard to the module about autism, I have remained in touch with its leader and the module remains online post-lockdown, meaning that students do not need to remember names and dates. In addition, the essay questions are now also given in advance to allow students to process them before the exam. So, although I cannot reverse my failure, I think my experience contributed in a small way to how this module is now examined.

Pre-diagnosis advocacy

Self-advocating may not always have such positive outcomes and may even be detrimental to seeking further support. Billy documented how she was put off from asking for help for the way she was feeling after a previous negative encounter when she had sought help to be diagnosed as autistic.

I was not diagnosed until I had finished my undergraduate. I sought help from the doctors during my second year and after several misdiagnoses, re-arranged appointments, and ten months, I was referred to a mental health specialist. After telling him how deeply sad, isolated and misunderstood I had been feeling, he suggested I take a bike ride next time I experience these feelings. In my shock at how easily he had minimalised my experiences, my concerns about my mental health and own safety, and dismissed these so easily, I could only respond that I could not ride a bike. He said "well then, maybe now's the time to learn". I stopped seeking help that day and struggled on for another two years alone. I have so much anger that I still haven't fully processed about that time. Anger and pity for my younger self. I got through it though, and I will work to ensure no one else feels that way again. I learnt to ride a bike during my masters, then how to drive for my PhD.

Figure 8.1: Untitled, by Billy

Billy's image shows a photo and descriptive text about her experience of trying to get some support for how she was feeling before she was diagnosed as autistic. Her writing portrays the deep sadness she was experiencing and the anger she felt at being dismissed. The impact of needing to wait another two years to gain the confidence to try and self-advocate again for support was clearly a struggle for her, but was also a catalyst for not wanting others to experience similar feelings. Advocating for a diagnosis, particularly as a woman, can be difficult due to societal beliefs about who can be autistic. Research documents that women traditionally get diagnosed as autistic later than men and are likely to receive other diagnoses first (Leedham *et al*, 2020). Receiving a level of disbelief and having to keep advocating for oneself at the beginning of a diagnostic journey may reduce a person's self-confidence and determination to advocate for the things that would make situations easier. Paricos *et al* (2024) explored how ten autistic women defined good quality of life and the factors they associated with it. They grouped responses into four themes: a positive sense of self, feeling supported, autonomy, and inclusion. Most relevant to Billy's experience of being misdiagnosed and not feeling listened to, is the theme of 'positive sense of self', where they highlight that being autistic did not affect quality of life, but that being diagnosed later (which, again, is common for autistic women) delayed

self-acceptance and therefore impacted it. Considering this time element, self-advocating for support, not being believed or being misunderstood and therefore turned away could significantly affect a person's acceptance of their own identity. Cassy also felt dismissed when trying to discuss things she was finding difficult before she self-identified as autistic:

'I've tried having conversations with my managers for myself. And they've kind of... They've kind of genuinely been dismissed before I've even got the conversation off the ground, you know, and I remember trying to talk to people in Student Services years ago who would be like, you know, there's no issue here, you're fine.'

(Cassy)

Traditionally, advocacy around autism has been done by parents or professionals rather than by autistic people themselves. Therefore, a person self-advocating may be a novel concept to many. It may be seen that, if a person is able to advocate for themselves, then they do not need support. Although this is noted in the literature by some scholars in the field of critical autism studies (for example, Brady & Cardin, 2021; McGuire, 2016), the notion that an autistic person may be able to self-advocate, rather than requiring the assistance of a friend or relative, is not commonly accepted. University staff in particular should expect autistic individuals (and those questioning whether they want to identify as autistic) to express their concerns through self-advocation as well as being advocated for by others.

Advocating for support with a diagnosis

Even with a formal diagnosis of autism, being able to self-advocate at university is still important. I believe that self-identification alone is valid, since waiting lists for formal diagnoses are so long on the NHS and private diagnoses are so expensive, however in order to access support in some situations proof is currently required. Removing the need for proof would reduce the barriers to support for autistic individuals but may also be open to abuse. If an individual has a formal diagnosis, navigating the process of disclosing this and working out the ways in which support can be

sought at university can be challenging. Some researchers highlight that universities want students to disclose diagnoses so that they can support them and reduce the chance of a crisis point being reached (Clouder *et al*, 2020; Van Hees *et al*, 2015). This requires trust in the systems of support and the staff who manage support for disabled students. Postgraduate autistic students may have been to another university before and, depending on their experiences there, the desire to disclose may be affected. Billy wanted to access support but found working out how to navigate the system difficult and off-putting:

> *'The processes for seeking support are not as clear or straightforward as they could be, the belief that because you got into uni – you'll be capable at uni.'*
>
> (Billy)

Billy's suggestion that there may be an assumption that university students are able to advocate for themselves, and that the onus is on them to work out the system is perhaps a disabling attitude. While this is a welcome counternarrative to the prevailing idea that autism is predominately characterised by negatives, it may also be disabling in this context for autistic students seeking support. Sarah also found self-advocating through the process and protocols of her university difficult. Specifically, she found it to be an exhausting fight, meaning she actually needed more support (in order to counteract the exhaustion) than she originally wanted to ask for:

> *'Because a lot of my energy has actually been spent, fighting for support. Because I've known without any of it I wouldn't manage. But because I've had to fight for it, I've needed more than I would have needed if it's actually just been smooth.'*
>
> (Sarah)

In Sarah's experience, if the process had been smoother, she may not have needed as much support, which would have likely saved the university money and/or time, so this would have positively impacted both parties. Price (2021) emphasises that accommodations or adjustments for disability can be ever-changing and unpredictable. Therefore, the fight for support and the need to self-advocate may be ongoing, creating additional labour for the disabled person. It is likely necessary for an autistic student to figure out how to navigate the system of support if they recognise that they will be unlikely to complete their studies without additional support. If a university culture existed in which all students were included, then the need for additional support may ne negated. Perhaps students think university will be different to school, or find navigating university support systems difficult and therefore do not advocate for support, leading to a crisis when the environment is no longer survivable. Considering that we know that students often only seek support when they are no longer able to manage in an environment, support systems for disabled students at universities need to be able to respond quickly, to ensure self-advocacy is listened to at critical times. Improving processes so that autistic students do not have to advocate so strongly would be beneficial to a wider range of people and the organisation as a whole, not just the autistic student.

The element of time

Both of the previous sections within this overarching theme of self-advocacy highlight the challenges of getting past gatekeepers to access support and the difficulties faced when navigating the support processes. It is worth considering the element of time at play here, such as Billy's experience of waiting for a diagnosis and the time Sarah had to spend fighting for support. Academia is concerned with speed and efficiency, particularly in relation to productivity and reducing the time spent on tasks, which can serve to increase its inaccessibility (Price, 2021; Rodgers *et al*, 2022). 'Crip time' has emerged in academia as a counterweight to the time pressures usually present in academia, in order to increase accessibility for disabled academics. Price (2021) notes that Covid-19 has made elements of crip time more mainstream and that slowness is not only becoming more acceptable, but people are actively advocating for it – for example, email signatures now often emphasise a person's hours of work. This suggests that the culture is shifting from a need for speed in academia to an acceptance that things may not occur quickly.

Autism also needs to be considered in the context of a fast-paced society. McGuire (2016) highlights campaigns about autism that have been featured on takeaway coffee cups and explains that diagnosis should be sought quickly to reduce wasted time seeking support. Although McGuire (2016) was making these arguments to support the campaigns of the time by organisations such as Autism Speaks to promote therapies to help 'cure' or reduce autism, the principle of ensuring quick diagnoses to enable support remains relevant. This is especially the case because, as Paricos *et al* (2024) discuss, the quality of life for autistic women can be influenced by understanding their autistic identity and sense of self. Therefore, understanding themselves at a younger age will lead to improvements in self-esteem and confidence.

Although slowness viewed through the lens of crip time may allow disabled academics more inclusivity in academia, in order to access the support that is currently set up for neurotypical academics, adjustments need to be put in place in a timely manner and they must be regularly reviewed. While adjustments (regardless of whether they are deemed reasonable) are beneficial in some ways, they can be used in the same way as a plaster, and not provide a complete answer or longer-term solution (Price, 2021). However, the current system for including disabled people in academia is based on requesting adjustments to work as close to the neurotypical norm as possible. Adjustments must be implemented quickly so that an autistic person can reap the benefits as soon as possible, but also so that any further accommodations that might be needed can be identified more quickly and easily (Dwyer, 2023). The disconnect between crip time, which may possibly be needed by the very people tasked with implementing adjustments, and the need for adjustments to be implemented quickly and in an unpredictable nature, is evident. For example, a standard adjustment that students often receive is extensions on assignments, which by definition acknowledges the need for extra time, but in order to receive such accommodations, evidence of disability is usually required, which can be slow to obtain. In addition, there may be waiting lists to receive support (such as waiting lists or money being available to pay for support). Price (2021) argues that time, particularly time spent waiting, causes harm that is not readily acknowledged. If an adjustment is eventually provided, the delay it took to implement is often overlooked and the focus is instead on the fact that the adjustment was made, which ignores the suffering of the individual

who may have been waiting for weeks or months. This also means that the time that higher education is taking to become truly inclusive for autistic people and to incorporate elements of Universal Design for Learning (UDL) is likely to ensure that autistic academics remain discriminated against and excluded.

Overall, a cultural shift is needed to consider time in more depth, both slowness and speed, and the role of time and responsiveness in creating more inclusivity in academia, alongside the need to listen to the advocacy of autistic people. This includes being more willing to accept the fact that women can be autistic and that they need that label if they are to access support, which will reduce the onus on autistic people to need to self-advocate. Working out how to access support at university and having to fight for it, like Sarah did, can be exhausting and can prevent an autistic individual from channelling their energy into academic endeavours. Therefore, if the need to self-advocate at university is reduced and any self-advocacy is acted upon quickly, autistic postgraduate students may be able to devote more time to their studies, which in turn will be beneficial to them as well as to the university.

Advocating for others

Some autistic people choose to advocate for others to improve inclusion and diversity in a world that is set up for a neurotypical norm. Advocating for others, rather than for oneself, may be easier as some of the emotion and personal consequences are removed (Lei & Russell, 2021). However, as Poppy highlights, being openly autistic and advocating for change can involve additional labour, even if it is on the behalf of others:

> '*It can mean that, like, the one person who does know anything about it [autism] ends up having to be the advocate for anyone who is autistic, which is not helpful because it means, like, you end up kind of outing yourself as being, like, that person who's always going to be, like, "but what about autistic people?"'*

> (Poppy)

This extra labour of advocating on others' behalf to ensure change in various situations in academia might be based on either a want for better inclusion, or a feeling of not fitting in. Craddock (2020) highlights that women advocating and engaging in activism regularly feel inadequate or guilty about either not being a good-enough activist or the lack of time they can devote to it. Craddock suggests that this is due to internalised gender stereotypes and constraints, but also that it might be intensified for neurodivergent women due to the intersectionality between societal attitudes towards gender and disability.

Poppy explains that, because she is knowledgeable about autism and identifies as autistic, she feels she is therefore labelled as the advocate who will voice her opinion on how autistic people can and should be included in any given situation. Feelings towards advocacy possibly depend upon the situation and whether there is a collective group of people advocating or whether one person feels like they are having to shoulder all of the effort. Pellicano *et al* (2022) suggest that research can evoke a sense of collective advocacy if multiple people share their stories. Botha and Frost (2020), meanwhile, suggest that positioning autism as part of a person's identity may increase stress as it requires constant battle against the prevalence of the medical model within society. While Poppy may choose to talk about some issues around access and inclusivity, the presumption from others about her ability and desire to advocate means that she carries extra responsibility and a burden that others have bestowed on her that she may not want. Regardless of whether a person is assumed to be an autism advocate or not, for advocacy to create change in academia, people need to listen and be open to the ideas that are on offer. Billy found that when she advocated for other autistic students at university, she felt that it was taken in a tokenistic manner and not the proper attention it deserved:

> *'It was definitely ticking boxes, and when I advocated for change during my master's, talking about better services and asking the university to listen to its students more, it became very defensive. People took it personally that we were wanting change.'*

(Billy)

Enabling autistic students to advocate for change might be a 'good look' for a university as they can claim to be encouraging the voices of disabled students, but, in reality, they rarely value the opinions that are forthcoming. Billy emphasises how she felt that the university just wanted to 'tick boxes' and was not actually interested in what she and others had to say. She also mentions that the university became defensive when she gave her opinion, suggesting that the people she was advocating to were not expecting any negative opinions to be shared, or any change suggested. There is therefore a disconnect between wanting to make changes based on the opinions of a student with lived experience of autism, and presenting a façade that they university has good intentions in order to ensure they are meeting equality and diversity initiatives and quotas. Advocacy at university and tokenism may therefore intersect, not just as part of research but also as part of wider university culture:

> *'Academia is tough, especially for autistic individuals who others often believe they know more about your experience as an autistic person than you.'*
>
> (Billy)

Potentially, although others may listen to the advocacy of an autistic student, they may hold ingrained stigmas and stereotypes about how an autistic person should feel or act. When presented with an autistic person who does not fit their expected ideas of autistic people, it is difficult for them to accept the things the person is advocating for as they may be outside expected and accepted norms. This might be particularly the case for autistic women, where stereotypes of how autistic women present are much less visible in societal discourse. It may be difficult for neurotypical people to understand what autistic people are advocating for. Creaven (2024) explains that this may be because disabilities that are not always immediately apparent can be difficult to understand or cater for. This is not to offer an excuse, but to explain a possible counternarrative and explanation that advocacy may not be being deliberately ignored. In addition, adjustments for a disability such as autism are based on the idea that an autistic person, or group of people, can predict the support they will need in the future and that the support needed will always be the

same (Price, 2024). The ultimate goal, of course, would be for advocating to be unnecessary even if the disability is not immediately apparent, such as often the case with autism.

Advocacy may have a place in academia, however, and particularly within student recruitment. I was employed as a 'Disability Champion', for which, despite the somewhat cringeworthy job title, I felt I could advocate for others. Disabled students were employed by the university disability service to share our stories of studying at the university and to talk about the support available, and how to access it, to current and prospective disabled students. When presenting, we were allowed to talk about what we wanted, with the only stipulation being that there needed to be at least one positive aspect. This freedom was surprising and demonstrated the level of trust and inclusiveness that we had achieved. By sharing experiences of our time as autistic students, we were advocating for change. We mainly presented to prospective students but some members of staff from the university disability services were frequently present. I liked this as it meant I could tell prospective students some things that I wished I had known before I started, to hopefully prevent them from making the same mistakes, but it also enabled the staff to hear some feedback, some of which was, I think, taken onboard. I was remunerated for this advocacy, financially, but also through the feeling that I was being listened to, which is possibly why it was such a positive experience, especially compared to Billy's feeling that she was not listened to and Poppy's discomfort with the extra labour. These three different experiences highlight how the experience of advocating for others can vary even when the same initial intention to foster change is the catalyst.

Concluding thoughts

Overall, advocating can require additional labour, which can be off-putting even if it is necessary to ensure equality. It is reasonable to assume that all autistic women may need to advocate for themselves or others at some point, whether that is to receive a diagnosis of autism or to be supported – both in academia or wider society – where a stereotypically male understanding of autism prevails. Advocacy may not be undertaken out of choice, but rather necessity, or to fulfill the desire of other people to learn more. The speed and ease with which a person moves from advocating to achieving their end goal is crucial in ensuring whether or

not they feel listened to and that they are worthy of the support they are asking for. Although speed in academia is its own broad subject, and has been challenged by theories and initiatives such as crip time, delay can be harmful if a person is waiting for something that will assist them in their studies or better include them in the university. Any waiting period should not be seen as a neutral entity. Ultimately, if there was more understanding of how much courage self-advocacy takes, then the responses of others towards the self-advocator may be more sympathetic and people may be more willing to assist. A strive towards an academic culture in which advocacy is not needed, due to inclusion being the norm, may be the utopic goal. However, until then, it is vital to reduce the need to advocate by ensuring systems and procedures for accessing support are easy to navigate and support is put in place quickly.

References

Bailey, K. M., Frost, K. M., Casagrande, K., & Ingersoll, B. (2020). The relationship between social experience and subjective well-being in autistic college students: A mixed methods study. *Autism*, **24**(5), 1081–1092. https://doi.org/10.1177/1362361319892457

Botha, M., & Frost, D. M. (2020). Extending the minority stress model to understand mental health problems experienced by the autistic population. *Society and mental health*, **10**(1), 20-34. https://doi.org/10.1177/2156869318804297

Brady, M. J., & Cardin, M. (2021). Your typical Atypical family: Streaming apolitical autism on Netflix. *Topia: Canadian Journal of Cultural Studies*, **42**, 96-116. https://doi.org/10.3138/topia-42-008

Chown, N., Beardon, L., Martin, N., & Ellis, S. (2016). Examining Intellectual Prowess, Not Social Difference: Removing Barriers from the Doctoral Viva for Autistic Candidates. *Journal of Inclusive Practice in Further and Higher Education* **6**(1), 22–38. https://openresearch.lsbu.ac.uk/item/87495

Clouder, L., Karakus, M., Cinotti, A., Ferreyra, M. V., Fierros, G. A., & Rojo, P. (2020). Neurodiversity in higher education: A narrative synthesis. *Higher Education*, **80**, 757–778. https://doi.org/10.1007/s10734-020-00513-6

Craddock, E. (2020). *Living against Austerity: A Feminist Investigation of Doing Activism and Being Activist*. Bristol University Press.

Creaven, A. M. (2024). Considering the sensory and social needs of disabled students in higher education: A call to return to the roots of universal design. *Policy Futures in Education*, 1-8. https://doi.org/10.1177/14782103241240808

Dwyer, P., Mineo, E., Mifsud, K., Lindholm, C., Gurba, A., & Waisman, T. C. (2023). Building Neurodiversity-Inclusive Postsecondary Campuses: Recommendations for Leaders in Higher Education. *Autism in Adulthood*, **5**(1), 1–14. https://doi.org/10.1089/aut.2021.0042

Garland-Thomson, R. (2002). Integrating Disability, Transforming Feminist Theory. *NWSA Journal* **14**(3), 1–32.

Hoyt, L. T., & Falconi, A. M. (2015). Puberty and perimenopause: Reproductive transitions and their implications for women's health. *Social Science and Medicine*, **132**, 103– 112. https://doi.org/10.1016/j.socscimed.2015.03.031

Leedham, A., Thompson, A. R., Smith, R., & Freeth, M. (2020). 'I was exhausted trying to figure it out': The experiences of females receiving an autism diagnosis in middle to late adulthood. *Autism*, **24**(1), 135-146. https://doi.org/10.1177/1362361319853442

Lei, J., & Russell, A. (2021). Understanding the role of self-determination in shaping university experiences for autistic and typically developing students in the United Kingdom. *Autism*, **25**(5), 1262-1278. https://doi.org/10.1177/1362361320984897

McGuire, A. (2016). *War on autism: On the cultural logic of normalized violence*. University of Michigan Press.

Paricos, A., Sturrock, A., Twomey, K., & Leadbitter, K. (2024). I'm not mad, bad, and dangerous... simply wired differently: Exploring factors contributing to good quality of life with autistic women. *Research in Autism Spectrum Disorders*, **112**, 102338. https://doi.org/10.1016/j.rasd.2024.102338

Pellicano, E., Lawson, W., Hall, G., Mahony, J., Lilley, R., Heyworth, M., Clapham, H., & Yudell, M. (2022). "I Knew She'd Get It, and Get Me": Participants' Perspectives of a Participatory Autism Research Project. *Autism in Adulthood*, **4**(2), 120-129. https://doi.org/10.1089/aut.2021.0039

Price, M. (2021). Time harms: Disabled faculty navigating the accommodations loop. *South Atlantic Quarterly*, **120**(2), 257-277. https://doi.org/10.1215/00382876-8915966

Price, M. (2024). *Crip Spacetime: Access, Failure, and Accountability in Academic Life*. Duke University Press.

Rodgers, J., Thorneycroft, R., Cook, P. S., Humphrys, E., Asquith, N. L., Yaghi, S. A., & Foulstone, A. (2023). Ableism in higher education: the negation of crip temporalities within the neoliberal academy. *Higher Education Research & Development*, **42**(6), 1482-1495. https://doi.org/10.1080/07294360.2022.2138277

Sapir, A., & Banai, A. (2023). Balancing attendance and disclosure: identity work of students with invisible disabilities. *Disability & Society*, 1-21. https://doi.org/10.1080/09687599.2023.2181765

Sinclair, J. (2005). *Autism network international: The development of a community and its culture.* www.autismnetworkinternational.org/History_of_ANI.html (accessed July 2024)

Van Hees, V., Moyson, T., & Roeyers, H. (2015). Higher Education Experiences of Students with Autism Spectrum Disorder: Challenges, Benefits and Support Needs. *Journal of Autism and Developmental Disorders*, **45**, 1673–1688. https://doi.org/10.1007/s10803-014-2324-2

Conclusion

Autistic women do not always fit the narratives of autism held by society, and thus throughout this book, I challenge these narratives by focusing solely on autistic women. Through reflecting on both my own experiences and those of the participants in my study, I have sought to contextualise autism within university life. I think autistic women's experiences at university – and more broadly in wider society – continue to be regularly erased, and throughout these chapters I have shared some first-hand experiences to contribute both to literature about autism and to suggest practical measures to increase inclusion at university. Considering the skills that autistic individuals can bring to research and academia in general, it is important that the voices of autistic women are amplified to highlight a more diverse academic landscape.

Focusing on how postgraduate students experience university may be beneficial to university structures and policies, especially as universities tend to revolve around undergraduate university students, and research about the autistic experience tends to explore only this group. As Botha (2021) highlights, the autistic academic experience is rarely spoken about and frequently silenced, which this book seeks to remedy. By presenting anecdotes of the autistic postgraduate woman, I challenge this silencing of any deviation from expected neurotypical approaches to academia. In addition, experiences as students can be intertwined with experiences as staff (in various contexts). This dichotomy of being both an autistic student and staff member at the same time should be considered in more detail, especially within the context of neoliberal institutions.

Throughout the different topics discussed in each chapter, two themes emerge: exclusion and camaraderie. Exclusion experienced by autistic women both at a societal and at a postgraduate academic level may reduce self-esteem and increase isolation. I have spoken about exclusion from various spaces due to the sensory overwhelm, and from other people within academia due to gender stereotypes and stigma. I have highlighted how autistic individuals can feel excluded by miscommunication, particularly if it is with people they need to work closely with such as PhD supervisors. This can increase the feeling of exclusion and of not being wanted in academia. Exclusion can also be felt when advocacy – either for oneself or for others – is not listened to or acted on. Being excluded in academia is likely to be exacerbated as an autistic woman due to the exclusion they face due to autism being considered a 'male condition'. Autistic academic women may therefore face a double exclusion – the exclusion of being an autistic academic and the exclusion of being an autistic woman.

However, what is also apparent is how camaraderie and community are positively impactful for autistic postgraduate women. This can take the form of finding other like-minded autistic researchers, by being supported at events such as conferences or by feeling confident enough to advocate for the needs of others. A sense of belonging can therefore be found. Although by sharing 'just' the experiences of myself and my PhD participants I cannot scientifically prove that camaraderie prevents or reduces exclusion as a postgraduate autistic woman, the stories strongly suggest there may be a link. This may be because finding a community and feeling a sense of belonging may be a protective factor against exclusion. This is not to say that exclusion will not be experienced, but that belonging to a community of autistic academics may ensure that being excluded is a less impactful experience.

A brief reflection on my PhD journey

The chapters of this book each look at specific aspects of the university experience, and each of these could be read as mostly separate areas which the participants of my PhD study and I felt were important. As discussed, however, there are some interlinking themes that run throughout the chapters, such as exclusion and camaraderie, and the overall experience of my PhD may not be evident. In addition, some

negativity may prevail at points in the chapters, however I do not feel that I or the participants have presented any of our experiences as overtly negative or positive. Generally, my PhD was enjoyable, particularly as the amount of autism research being produced by autistic people exploded while I was studying, so it was, and continues to be, an exciting time to be in the field. I was introduced to many skills and techniques for research as part of my PhD. The impacts of studying during the UK COVID-lockdowns were significant and made me reflect that, although I found (and still find) environments to be difficult due to noise or other sensory factors, I prefer to be physically a part of office life and events. I have not really explored in significant depth the impact of lockdown in this book. I grappled with whether to include such a focus, but, as I wanted this book to remain relevant to people who may be able to study without having to experience lockdown, I chose not to. I appreciate the effects of lockdown are still with us, and the pandemic has undoubtedly permanently changed ways of working and the experience of working and studying in academia. Overall, all of the experiences that I have encountered have shaped how I feel as an autistic researcher, and also as an academic in the field of autism research.

A note on relevance

Throughout this book, I focus on autism as opposed to referring more broadly to neurodivergence. I acknowledge that the exploration of neurodiversity as a whole to include all minds, and that categorising people as neurotypical or neurodivergent is becoming more usual in academic work. I believe that, one day, even these broad categorisations may cease to exist. I have predominately centred on autism because that was the focus of my PhD, although where relevant I broadened my focus in my writing. When I first submitted my PhD research proposal in 2017, I could only locate three research papers on the experience of autistic people in higher education, none of which were published in the UK (this is not to say they may not have existed, but I was unable to locate them). The interest in autistic students, and more broadly in neurodiversity, has since grown immensely and the field remains ever changing and evolving. I wanted to earnestly include the postgraduate women who took part in my study, and to do that I felt I needed to predominantly focus on the experiences of autistic postgraduates. All the participants came to the research with other intersectionalities besides being just autistic and women, and this may be apparent through the

experiences related within this book. I believe that autism and the experiences documented in this book can be used as a metaphorical springboard to highlight good practice and to prompt change that may be relevant to many more students and academics than just autistic postgraduate students. I hope that what I have presented in this book can be considered from both within and outside the confines of autism.

Potential change

Change is clearly needed in order to ensure that autistic postgraduate women are better included in academia. Pleschová *et al* (2021) highlight that change can be difficult as it requires trust and a willingness to be vulnerable, to the opinions and intentions of others who are suggesting changes. Although difficult, change can also foster growth and increase inclusivity. I argue that a culture change is needed within universities, and by extension in wider society, towards inclusivity and acceptance of difference, particularly towards invisible disabilities and differences. By 'invisible', I include intersections beyond invisible disability such as social class. In an ideal world, this would mean valuing everybody as simply human, rather than by their deficits or differences compared to a mythical norm. The notion of acceptance needs to be championed for postgraduate students and staff as well, which could increase a sense of belonging and the enhance experiences of being part of a community of researchers. The fuzzy boundaries that can exist between being a student and a staff member demonstrate how the neoliberal university privileges students (the consumer) over staff (the producer, who may teach the consumer) and the vicious cycle it can create. I argue that universities should be willing to give those who occupy both a student and a staff role receive the same disability support in both roles, primarily to support them but also to provide positive role models to disabled students.

The concept of Universal Design for Learning (UDL) needs greater exploration and implementation in universities, particularly in relation to neurodiversity. Incorporating its principles could support autistic students to feel included in academia, which currently raises several barriers despite the positive skills and abilities that autistic people are likely to bring to the research landscape. Although adapting an environment and culture to be more inclusive for autistic individuals may be intimidating, Spaeth and Pearson (2023) emphasise that being an expert in neurodiversity is

not important, but being flexible and willing to learn and improve is. They also highlight that inclusion is an ongoing process and therefore making and learning from mistakes is part of that process and not something to be viewed negatively. An inclusive environment in academia could also be improved if academics reflected upon the ways in which they communicate with others and the innate biases they hold against those at university who are not the same neurotype as them. By appreciating the positives that communicating across neurotypes can bring, neuro-mixed academic spaces may be created, prompting collaboration and more rigorous research (Bertilsdotter Rosqvist *et al*, 2023). This of course includes trust within the culture of academia, and the belief that autistic people are experts of their own experience as well as being capable of researching topics outside the sphere of autism. Therefore, the most important thing an individual academic can do for an autistic postgraduate woman is to make time to ask them about their academic experiences, to listen, and to be open to changing practices to help improve any negative or difficult aspects of academia.

A final note

Throughout this book, my aim has been to give some insight into some of the experiences that an autistic postgraduate woman might have at university, through both academic insights, my personal experiences, and the experiences of the research participants. In illuminating how autistic women experience university, I showcase how a marginalised group, both within autism discourse and society, respond to alienation and exclusion. My own position as an autistic women researcher in the field of disability and my own lived experience have undoubtedly shaped this book, and for that I do not apologise. These stories will not resonate with every autistic postgraduate woman and they are not meant to, but elements of them may be relatable and inspire change. I aim to challenge current, generally negative, thinking about autism, particularly about women, and to encourage reflection on whether current academic practices are fit for purpose and whether they are inclusive. I want to contribute to the growing literature written by and about autistic women, to be part of the change against the silencing of the stories of autistic women.

References

Bertilsdotter Rosqvist, H., Botha, M., Hens, K., O'Donoghue, S., Pearson, A., & Stenning, A. (2023). Cutting our own keys: New possibilities of neurodivergent storying in research. *Autism*, **27**(5), 1235-1244. https://doi.org/10.1177/13623613221132107

Botha, M. (2021). Academic, activist, or advocate? Angry, entangled, and emerging: A critical reflection on autism knowledge production. *Frontiers in Psychology*, **12**, 727542. https://doi.org/10.3389/fpsyg.2021.727542

Pleschová, G., Roxå, T., Thomson, K. E., & Felten, P. (2021). Conversations that make meaningful change in teaching, teachers, and academic development. *International Journal for Academic Development*, **26**(3), 201-209. https://doi.org/10.1080/1360144X.2021.1958446

Spaeth, E., & Pearson, A. (2023). A reflective analysis on how to promote a positive learning experience for neurodivergent students. *Journal of Perspectives in Applied Academic Practice*, **11**(2). https://doi.org/10.56433/jpaap.v11i2.517

Understanding Others in a Neurodiverse World

A Radical Perspective on Communication and Shared Meaning

Dr Gemma Williams

For a long time, researchers have thought that social communication difficulties experienced by autistic people are due to cognitive and social 'deficits'. This book offers a neurodiversity-affirming alternative to this problematic approach, by presenting a novel perspective on cross-neurotype communication, for example between autistic and non-autistic people.

ISBN: 9781803883717

To order visit:
pavpub.com/clearance/understanding-others-in-a-neurodiverse-world-a-radical-perspective-on-communication-and-shared-meaning

Autism and the Law
Navigating a legal minefield

Adam Feinstein

Cover image © 2024
Daisy Whittle

Written by a leading author and researcher on autism with contributions from an autistic legal expert, this definitive handbook provides guidance on the rights of autistic people and their families across the lifespan.

ISBN: 9781803883205

To order visit:
pavpub.com/clearance/autism-and-the-law-navigating-a-legal-minefield

University: The Autistic Guide
Everything You Need to Survive and Thrive

Dr Harriet Axbey

This helpful and informative handbook is a trusty guide to starting university for autistic young people, providing support and useful tips for what will be the biggest transition students will have ever experienced.

ISBN: 9781803882543

To order visit:
pavpub.com/clearance/university-the-autistic-guide-everything-you-need-to-survive-and-thrive

Autistic Masking

Understanding Identity Management and the Role of Stigma

Amy Pearson and Kieran Rose

This book aims to define the process of autistic masking and the underlying reasons for its existence. It will consider the social context, including an individual's response to stigma or trauma, that facilitates impression management.

ISBN: 9781803882116

To order visit:
pavpub.com/clearance/autistic-masking-understanding-identity-management